IMAGES
of America

GLEN COVE
REVISITED

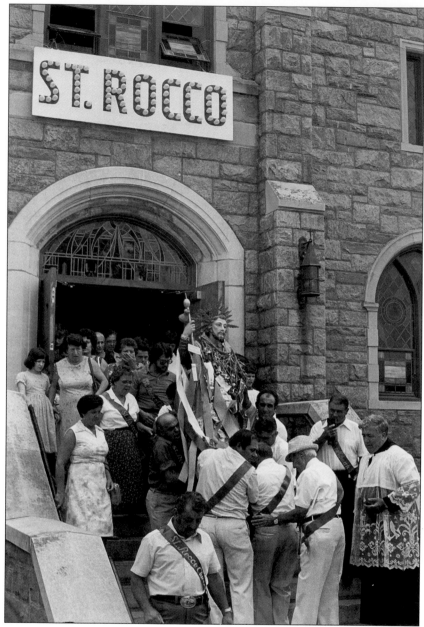

St. Rocco's Feast, 1978. St. Rocco's Church, designed by Michael Pascucci in 1937 and built by local men, represented the fulfillment of the Italian community's dream to have its own parish. When Fr. Eligio Della Rosa returned to St. Rocco's as pastor in 1974, he revived St. Rocco's Feast, a tradition that had been discontinued in the 1950s. The six-day celebration is known regionally as the "Best Feast in the East." (Courtesy of the author.)

On the Cover: The New York Yacht Club Regatta, 1927. The annual New York Yacht Club Regatta, once held every August in Hempstead Harbor, was a sight to behold. This view, looking out across the lawns, was taken from the porches of the resort hotel, the Hall. (Courtesy of Richard Reynolds.)

IMAGES of America

GLEN COVE REVISITED

To Lynn
Best wishes

Joan Harrison

ARCADIA
PUBLISHING

Published by Arcadia Publishing
Charleston SC, Chicago IL, Portsmouth NH, San Francisco CA

Printed in the United States of America

Library of Congress Control Number: 2009939873

For all general information contact Arcadia Publishing at:
Telephone 843-853-2070
Fax 843-853-0044
E-mail sales@arcadiapublishing.com
For customer service and orders:
Toll-Free 1-888-313-2665

Visit us on the Internet at www.arcadiapublishing.com

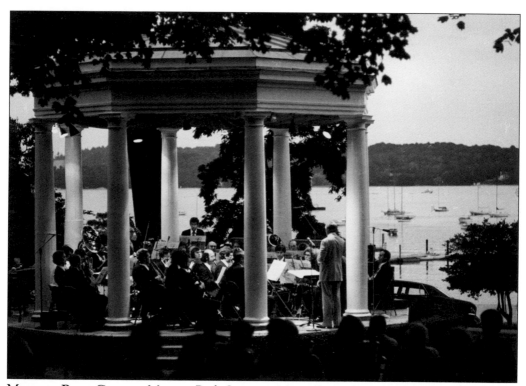

MORGAN PARK GAZEBO. Morgan Park Summer Music Festival was founded in 1959 during the administration of Mayor Joseph Suozzi and was underwritten through the benevolence of Laura Richardson Pratt. This annual free music, dance, and theater series, run by a nonprofit volunteer organization guided by Marguerite Suozzi, celebrated its 50th anniversary in 2009. The gazebo has become the symbol of Glen Cove. (Photograph by Robert Smith; courtesy of Marguerite Suozzi.)

CONTENTS

ACKNOWLEDGMENTS

My sincere thanks go to the people of Glen Cove, who have shared their photographs, memories, and life stories to enrich the recorded history of this city that we all love so much. I am deeply indebted to the trustees and staff of the Glen Cove Public Library, particularly director Antonia Petrash and librarians Carol Stern and Elizabeth Cameron, who graciously opened the Robert R. Coles History Room archives and supported this endeavor with their hearts. Without them, there would not be a book or a repository to preserve our past. Many thanks to the board of the North Shore Historical Museum for the use of the Pratt photographs and for permitting me to work with them toward making a "museum with walls" a reality. Sincere thanks go to Long Island University for supporting my research and to Landing Bakery, Charlie's Deli, and Landing Pride Civic Association for contributing to our neighborhood's sense of community. Above all, I am eternally grateful to my family—Michael, Emily, and Chloe—for their creative and critical input, and above all for their patience and loving support.

Photographs from private collections are credited as such. All other images are from the Robert R. Coles Long Island History Room Archive, Glen Cove Public Library.

INTRODUCTION

In the introduction to the 1868 bicentennial commemorative book, elders C. B. Grumman and J. T. Bowne wrote: "Unless we photograph the present and save, in some such way as this, the past from oblivion, much that is familiarly known to us of its present and past history will be a blank to those who shall follow us."

Unfortunately this small volume was produced before photographs could be incorporated with text, and not a single image of that eventful celebration survives. Compiling photographs and publishing local history fills in these blanks and makes their legacy accessible. It ensures that the visual story will not disappear, even as the landscape and demographics of the city change seismically.

Images of America: *Glen Cove* gave the reader an overview of an extremely complex city history by focusing on the diverse geographic areas and multiethnic populace of the community from its founding as Musketa Cove in 1668 until its urban renewal in the 1970s. *Glen Cove Revisited* examines the community starting with its official naming in 1834 and explores how a rural mill town paradoxically became both a 19th-century industrial center and a resort enclave that sheltered the country estates of the financiers and industrialists who shaped America. In this second book, there is a greater focus on the individuals who created the community and the interrelationships between the immigrants who came to live and work here and the privileged class who employed them and became patrons of the city.

In 1668, the hills surrounding Hempstead Harbor were covered with verdant forests. The creek was a sinuous channel that snaked its way to the sound through a rush-filled marsh. Freshwater springs were in abundance, and the Long Island Sound teemed with marine life. Song- and shorebirds filled the skies, and wildlife was plentiful. Until Joseph Carpenter came from Rhode Island and founded Musketa Cove plantation, this paradise was the domain of the few remaining Matinecock Indians. Under Carpenter and the original proprietors, the settlers built mills and earthen dams to create the great millponds, Upper and Lower Glen Lake, which divided the city in half. As discord with England grew, the centennial of Musketa Cove passed without notice or comment by the 200 or so colonists who lived there.

In 1834, the name Musketa Cove was shed for the more positively descriptive appellation "Glen Cove," and in this same decade in which photography was invented, the town began to grow and develop into the city it ultimately became. William Weeks, a farm boy from Red Spring, moved 1 mile south to find his fortune closer to the active shorefront. He organized the building of a steamboat dock and the construction of the Pavilion Hotel in what became the Landing. With other local businessmen, he started a mutual insurance concern and the first fire company.

In the 1850s, the Duryea starch works was built on the creek, beginning the industrial era. Irish émigrés arrived to work in the factory and stayed to live. An enormous celebration was held for the 200th anniversary of the settlement, with speeches, clambakes, and a parade. A branch of the railroad came to town, industry grew, and waves of immigrants arrived from Europe, particularly

from Poland and Italy. These skilled craftsmen built and served the "Gold Coast." Charles Pratt, J. P. Morgan Jr., Joseph DeLamar, F. W. Woolworth, and other scions of American business and industry found Glen Cove to be the perfect location for their palatial country estates. At the beginning of the 20th century, E. R. Ladew's leatherworks replaced the starch factory as the main employer, and the opulent life style of the Ladew family at Elsinore kept Glen Cove in the society pages.

Shortly after the United States entered World War I, Glen Cove officially became a city. In 1918, Dr. James E. Burns was elected mayor, and under his aegis, Glen Cove was developed and modernized. During that year, the Village Justice Courts Building, now home of the North Shore Historical Museum, was used as a quarantine hospital for the victims of the flu pandemic. In the 1920s, Glen Cove was a popular port for rumrunners, and the speakeasies were well supplied. The 1930s brought the straightening of the creek, the final filling of the millponds, and an outpouring of munificence by the Pratt and Morgan families. The schools, library, post office, and community hospital benefited from the largesse of the Pratt family, and Morgan Park, constructed by "Jack" Morgan as a memorial to his beloved "Jessie," ensured a place of respite and beach rights to every city resident.

By World War II, Glen Cove was a complex melting pot of intermarried families with deep roots and strong ties. The war hit the city hard, and things changed forever. Both men and women served their country, and some made the ultimate sacrifice. After the war, the rural landscape gave way to vast housing developments for returning GIs and the families they quickly began. The magnificent ships were gone from the harbor forever, and many of the estates were leveled or repurposed.

In the 1950s, the southern part of the city, dating from the starch works period, was razed and rebuilt, and Latino immigration began, first from Puerto Rico and later from every part of South and Central America. In 1968, a yearlong celebration marked the Tricentennial of the settlement of Musketa Cove and the start of a new era. In the 1970s, much of Glen Street and most of School Street were dismantled under urban renewal and slowly, during the next 20 years, reconstructed into the city we see today.

The beginning of the 21st century has seen the closing of the last big factories, Konica Minolta and Photocircuits, and the end of the industrial age. There is enormous pressure toward large-scale high-rise development and a renewed interest in community with open public discourse as to the future of Glen Cove. As choices are made, the words of elders Grumman and Bowne once again seem startlingly relevant. Concluding their remarks in the bicentennial volume, they wrote: "Let it not be said of you that the lessons of the past have fallen upon indifferent minds; that the monuments you build today will be the mockeries of your children tomorrow."

In these photographs, enjoy the glow of the Gold Coast as it once was and make a wish that the heart of it remains for your children and their children's children to enjoy.

One

OLD GLEN COVE

For its first 150 years, Musketa Cove settlement was a sleepy mill town surrounded by farms. This began to change in the second quarter of the 19th century, when William Weeks organized the building of the steamboat dock and the Pavilion Hotel in Cape Breton. Aware of the catastrophic losses after the great fire of 1836 in New York City, Weeks also persuaded the local business community to form the Glen Cove Mutual Insurance Company and an early fire company, which he served as chief. About this time, Musketa (pronounced "mosquito") Cove, renamed itself Glen Cove to distance itself from the negative image of stinging insects. Tourism flourished, and excursionists arrived daily on the steamboat that stopped at the Landing, as the area quickly came to be known.

In the 1850s, the Duryea family opened a cornstarch works, which at its height employed 600 workers, primarily Irish. Glen Cove became a company town, with many inhabitants living in workers housing on Brick Row and Wooden Row. They shopped in the company-owned Protective Union Store. The starch works won international renown and flourished until it became more cost effective to move the concern to the midwestern corn belt.

The bicentennial year, 1868, was marked by an enormous community-wide celebration. By 1900, Glen Cove was both a company town supported by the Ladew leatherworks, which had replaced the starch industry, and a rural hamlet. Great waves of Polish refugees and Italian immigrants came to live and work in the cove. The area became the heart of the Gold Coast, the country home to the baronial estates of the financiers and titans of industry who built America.

In 1918, when Glen Cove officially became a city, Mayor Dr. James E. Burns presided over the city council and oversaw the development of building codes, sanitation, public health, and the paving of the roads. During his six terms in office, he was the guiding force who brought the city into modern times.

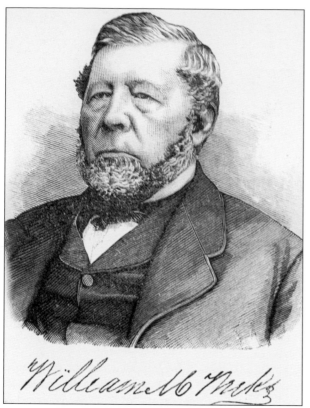

WILLIAM MUDGE WEEKS, 1803–1883. Lauded by W. W. Munsell's *History of Queens County* as "One of Glen Cove's most useful citizens," William Weeks was an entrepreneur who had a major and far-reaching influence on the city. In addition to his business acumen in developing the Landing and the Mutual Insurance Company, Weeks was a partner in an auction and commission business in New York City.

THE LANDING, 1875. This photograph of the Landing by George B. Brainerd is one of the earliest known pictures of the area. The view was taken looking east from the beach across the steamboat landing and up toward the Pavilion Hotel and the waterfront homes of Edgar Duryea and actor and playwright Charles Vincent.

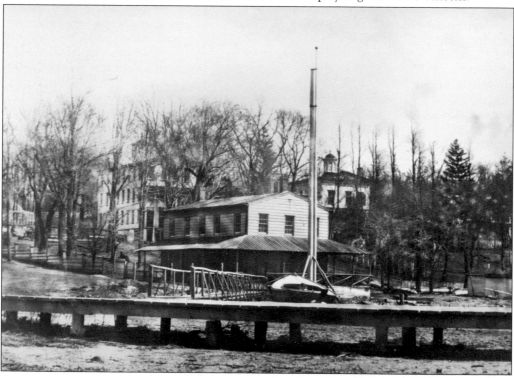

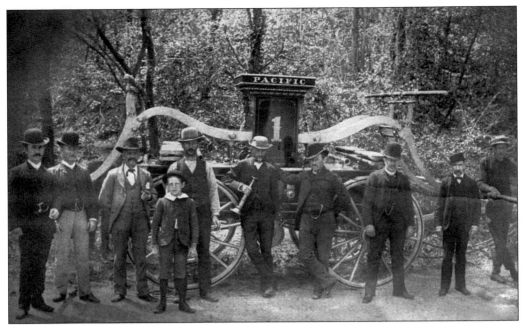

PACIFIC ENGINE COMPANY NO. 1, 1870. In 1837, a group of concerned citizens, at the insistence of the Glen Cove Mutual Insurance Company, met to form a volunteer fire department. William Weeks was elected chief, and funds were raised to purchase "Old Ironsides," a hand pumper. In 1867, the department's name was changed to Pacific Engine Company No. 1.

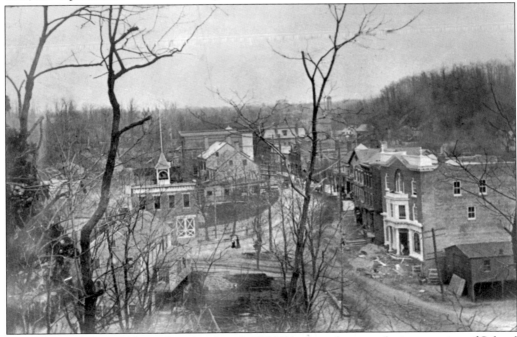

VIEW FROM THE HILL, 1899. This view from Mill Hill looking down on the intersection of School and Glen Streets shows the second firehouse, with the first Oriental Hotel, formerly a doctor's residence, in front the Glen Cove Mutual Life Insurance building. Village hall is across the street, and off in the far distance is the St. Patrick's Church bell tower.

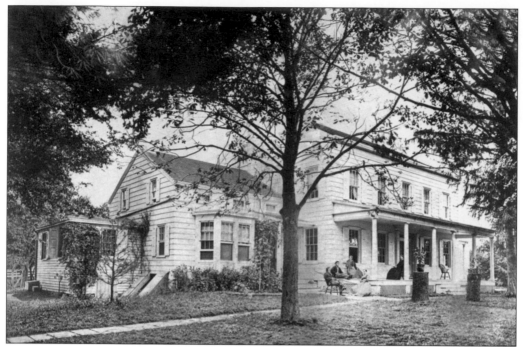

Mudge Homestead, 1875. The Mudge family traced its ancestry in America back to 1637. They were among the first settlers in Glen Cove and among the last of the founding families to leave. Sterling Mudge still resided in his family homestead at the top of Mill Hill on the Place during the 1968 Tricentennial. (Courtesy of Vincent Martinez.)

Mill Hill, 1902. J. H. Donohue photographed sledding on Mill Hill during the snowy winter of 1902. It was at the bottom of this steep incline on Killbuck Brook, a freshwater stream, that Joseph Carpenter built the first sawmill. Today the stream is dry, and the hill ends at the arterial highway. (Courtesy of Edna Dorfman Freeman.)

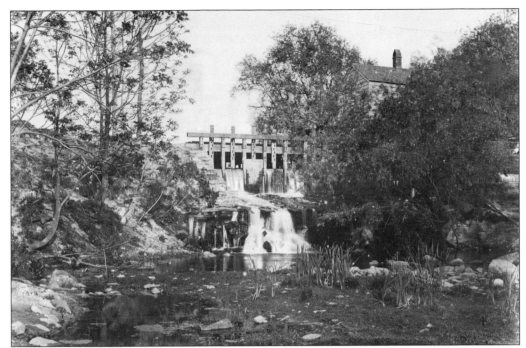

UPPER FALLS, 1900. Glen Cove was divided in two by the millponds, known as Upper and Lower Glen Lake. These falls were by the mill on the upper dam, where Pulaski Street is located. In the early years, only this passage and a footbridge connected the two halves of the city.

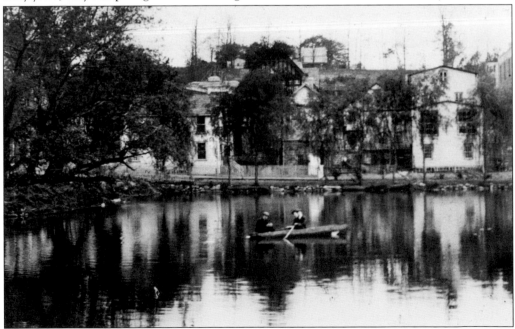

UPPER GLEN LAKE, 1900. The lakes were Glen Cove's principle source of ice and provided for good skating in the winter and trout fishing and boating in the summer. An early newspaper clipping recounts the story of an errant steer that escaped the slaughterhouse on the southwestern edge of the lake and managed to gore the butcher and swim across before being caught by six men.

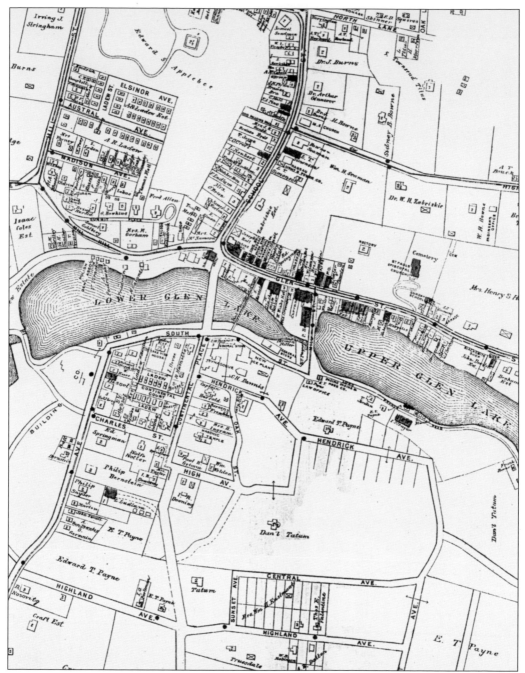

E. BELCHER HYDE MAP, 1914. The millponds Upper and Lower Glen Lakes were a beautiful and intrinsic part of early life in the community. Later, irrelevant to the local economy, they became garbage-filled eyesores that bred vermin and disease. By the 1930s, they were filled in, and only a small portion of the lower lake remained.

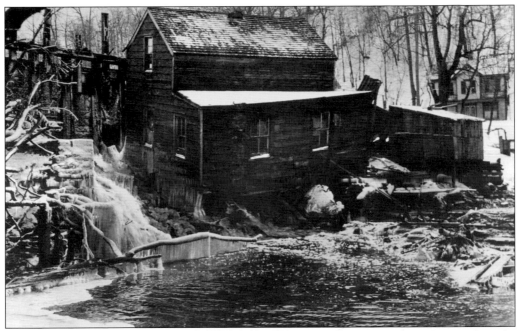

WATERGATE TENDER'S HOUSE. After the washout of the upper dam in the 1850s, the starch works had it reconstructed, providing a spillway and watergate tender's house. This replaced the old three-story Kirk Mill, which had operated into the 1840s.

LOWER DAM, 1900. Capt. John Walton and sons, wealthy millers and alleged smugglers, constructed the third, lower dam in the 1700s. Freshets destroyed the milldams repeatedly in the 19th century, but they were always quickly rebuilt and the mills put back in operation.

BRIDGE STREET, 1905. Children with their schoolbooks amble along Bridge Street, built as a vehicular thoroughfare in 1902. The Crystal Springs Ice Plant Hygeia Waters sits just below the bridge on the left. The pure spring located here and the millponds were sourced for ice in the days before electric refrigeration. In 1914, a pasteurized milk depot was located at the bridge.

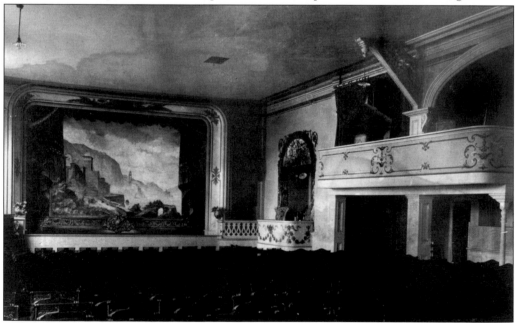

OPERA HOUSE, 1900. The opera house in south Glen Cove had a large stage, fine scenery, and both gas and electric lighting. With two galleries and a capacity of 500, it became a popular venue for silent movies. Later it became Congregation Tifereth Israel's synagogue, and it was demolished in 1926 for the construction of the new temple, now the First Baptist Church.

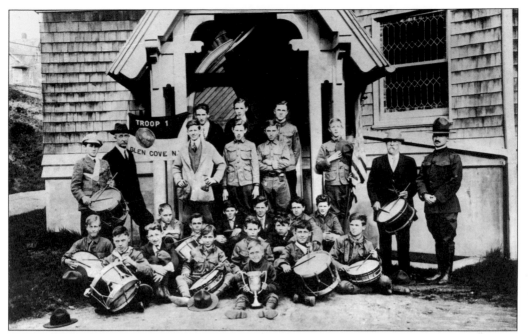

BOY SCOUT TROOP NO. 1, 1911. George DuPont Pratt, son of Charles Pratt and friend of Theodore Roosevelt, was one of the founding fathers of the Boy Scouts of America. His troop, affiliated with the First Presbyterian Church of Glen Cove, stands in front of the church building in its original location on Hendricks Avenue.

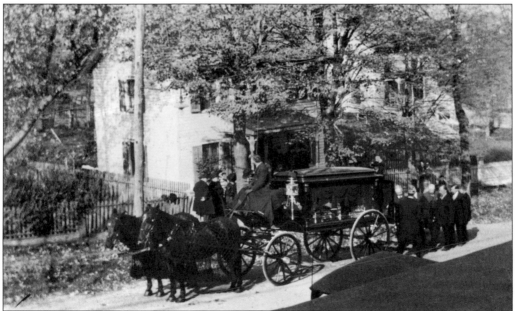

FUNERAL ON CECIL AVENUE, 1890. Although the name of the deceased, who lived on Cecil Avenue, is unknown, an image of his funeral cortege was recorded for posterity. The horses wear Victorian mourning netting. This old, predominantly Irish and African American sector of the city fell into extreme disrepair, and 40 acres of the neighborhood were demolished and rebuilt in the 1960s.

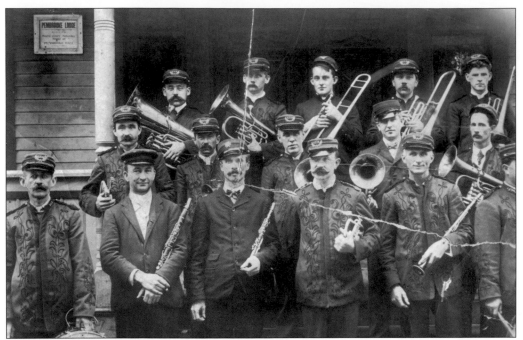

GLEN COVE BAND, 1900. Edward Dailey was bandmaster of the popular Glen Cove Band, seen here in front of Pembrooke Hall. The hall, home to Glen Cove's oldest fraternal organization, Pembrooke Lodge No. 73 I.O.O.F., was erected on School Street in 1891 and served as a location for events requiring an auditorium smaller than the opera house. In 1946, the building, repurposed into Glen Sportswear, was totally destroyed by fire.

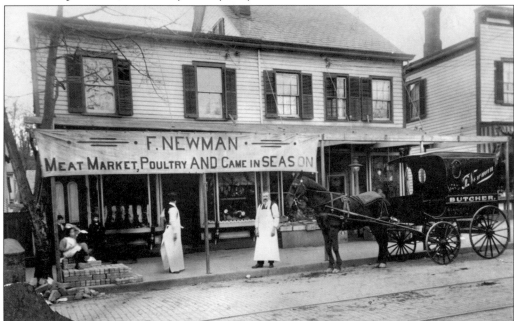

F. NEWMAN'S STORE, 1905. F. Newman's store, at 7 School Street, offered fine quality meats, poultry, and seasonal game for sale. It was just one of the many quality butchers and fine food markets that made shopping in the old city such a pleasure.

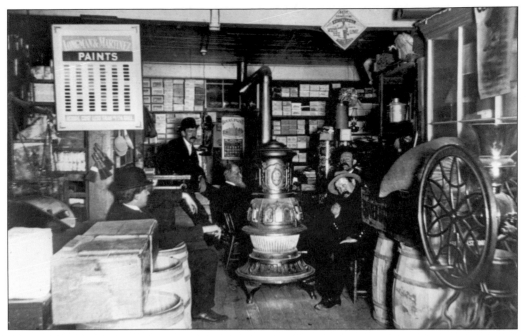

GENERAL STORE INTERIOR, 1890. This general store functioned as a post office, a general news distribution center, and a courthouse. In 1853, a large group was gathered at William Harrell's establishment for a trial when the floor gave way, hurling a burning stove and the crowd into the cellar. One man was killed and others suffered burns and broken limbs.

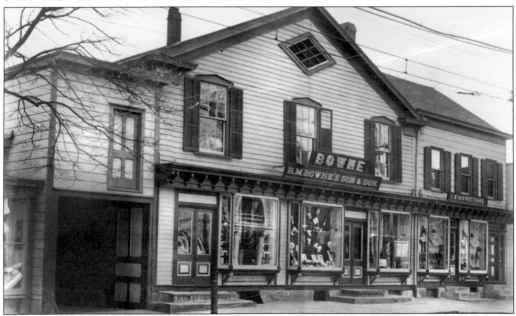

R. M. BOWNE'S STORE, 1900. Bowne's and Son Store, on Glen Street west of the footbridge over the lower lake, was the largest, best-provisioned establishment in town. It sold groceries, dry goods, agricultural implements, and the latest designs in wallpaper. After an 1893 incident in which a bear terrorized town, old man Bowne calmed children's fears by showing them the moth-eaten foot of an animal he had shot years earlier.

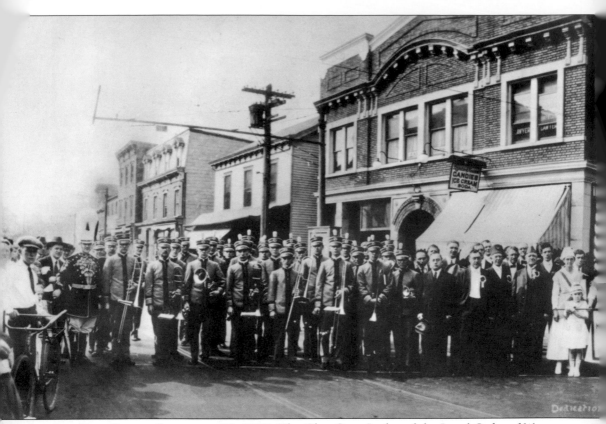

OLD POST OFFICE, SEPTEMBER 26, 1920. The Glen Cove Lodge of the Loyal Order of Moose, organized in 1917, contributed to the protection of orphans and care of the aged. The parade, celebrating the new Moose Home, gathered in front of the post office on Glen Street. This Tudor-

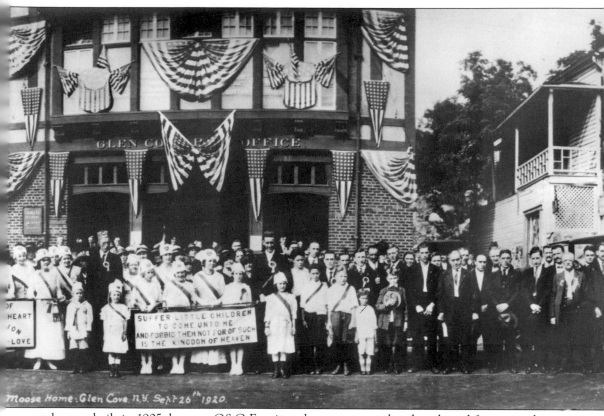

GLEN COVE POST OFFICE

SUFFER LITTLE CHILDREN
TO COME UNTO ME
AND FORBID THEM NOT FOR OF SUCH
IS THE KINGDOM OF HEAVEN

Moose Home. Glen Cove. N.Y. Sept 26th 1920.

style gem, built in 1905, became G&G Furniture but was restored and readapted for use as the offices of Smiros and Smiros, architects.

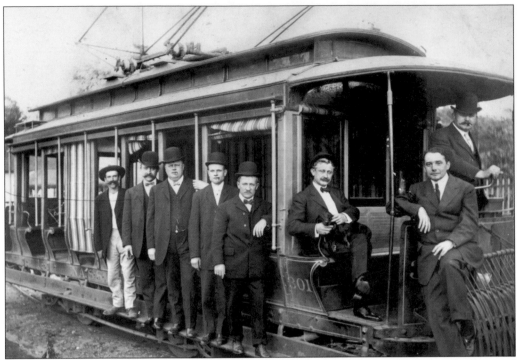

TROLLEY, 1901. The single-track trolley, which paralleled the Long Island Rail Road tracks, conveyed passengers from Sea Cliff Station to the Landing's dock. The trolleys had long poles sticking out in front to rouse goats sleeping on the tracks near the station. Service ended about 1924.

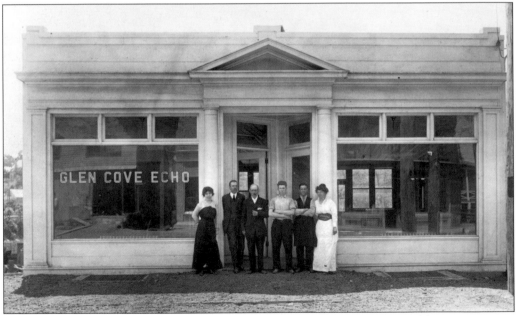

GLEN COVE ECHO, **1910.** The *Glen Cove Echo* was founded in 1875 by Buehl G. Davis as an alternative voice to the *Glen Cove Gazette,* an arm of the starch works. The *Echo* was instrumental in swaying public opinion toward choosing the city form of government for Glen Cove. Its office was located on West Glen Street, and it remained a family business for 85 years.

SINGER'S DEPARTMENT STORE, 1920. Singer's clothing emporium was a village institution that developed from the peddling business of Lithuanian Jewish immigrant Bernard Singer. Singer's was the place to buy lingerie, and Mrs. J. P. Morgan Jr. (Jane) purchased her corsets there. From left to right are Lena Singer, Bernard Singer, and Willam Zatlin. (Courtesy of Burton Singer.)

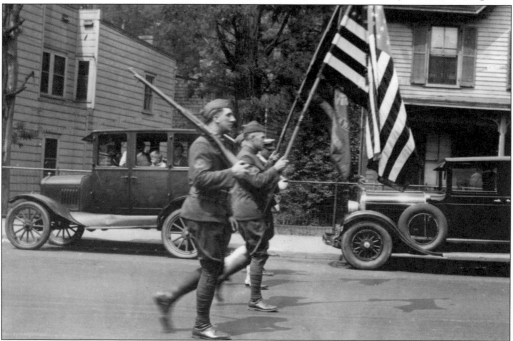

PARADE ON SCHOOL STREET, 1926. William Spennecke (man holding rifle), a World War I veteran and model for the Library Doughboy Monument, parades down Glen Street opposite the Cove Theatre. Spennecke, who marched in uniform in the Memorial Day event for six decades, was born in the Landing. He served as a mechanic attached to Battery D, 20th Field Artillery and received a Silver Star for heroism. (Courtesy of Ben Dunne and Brenda Dunne Brett.)

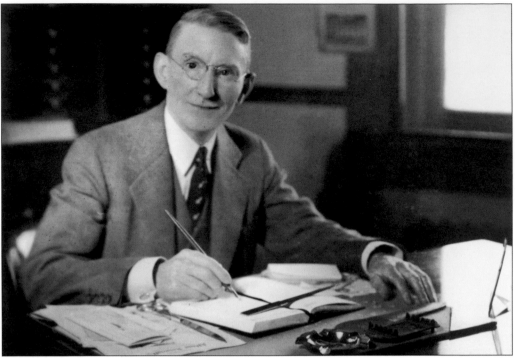

DR. JAMES E. BURNS, MAYOR, 1930. James Burns, an Irish Catholic physician and quintessential politician, was the first mayor of Glen Cove. He presided over the city from 1918 to 1925 and again from 1930 to 1933. A bachelor, bank founder, and devoted doctor, Burns worked tirelessly for the public good. He advocated for public health and women's suffrage, and served as postmaster from 1933 to 1948.

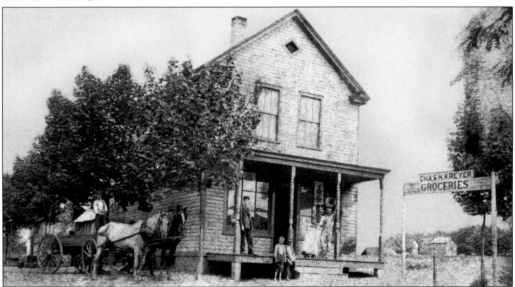

KREYER'S GROCERY, AROUND 1895. Kreyer's grocery store in the Landing was just one of many small, family-owned businesses in the city. Glen Covers pride themselves on how many generations of their families have lived in the city. The Kreyer family still resides in the Landing a century later. (Courtesy of Steve Kreyer.)

Two

THE WATERFRONT

The location of Musketa Cove settlement was chosen for its protected creek and proximity to the navigable waters of Hempstead Harbor. Long Island Sound teemed with fish, eels, and terrapin. Shellfish were also found in abundance, providing food and income. With the discovery of clay, wharves were built in the creek and at its mouth to expedite shipping. Sloops and schooners moved produce to and from the area by way of Dr. Thomas Garvie's dock. This was the center of waterfront activity until the founding of the Landing and the arrival of the steamboat.

The first steamboat to ply the waters was the *Linnaeus*, followed by many others, including the *Glen Cove*, the ill-fated *Seawanhaka*, and the *Idlewild*. The Landing put Glen Cove on the map, and excursion boats brought tourists. Financiers and members of the social register found Glen Cove a convenient place to summer, as it was an easy commute to the financial district by steam yacht.

Pleasure boating started in Hempstead Harbor in the 1830s with the New York Yacht Club's regatta, and in 1904, Yacht Station No. 10's clubhouse was moved to the Landing. Hempstead Harbour Club was founded in the 1890s and was followed much later by the Glen Cove Yacht Club. A mammoth breakwater was built, creating a safer anchorage, and the sheltered bays and quiet coves along the shorefront made Glen Cove a popular port for smugglers and rumrunners. Great pleasure vessels filled the cove until World War II.

Industry kept the creek a busy place of commerce. Corn, hides, silks, and dye were shipped in from all over the world. "Glen Cove made" products were shipped out. In the 1930s, the U.S. Army Corps of Engineers dredged and straightened the meandering creek bed, removing most of the sea of rushes that had given Musketa Cove its name. During World War II, Li Tungsten, a great smelting refinery, operated there. Now that the last great factories are shuttered and industrial pollution is largely remediated, shorefront use is primarily recreational. The present plan for waterfront redevelopment as a luxury high-rise community is a source of great controversy within the city.

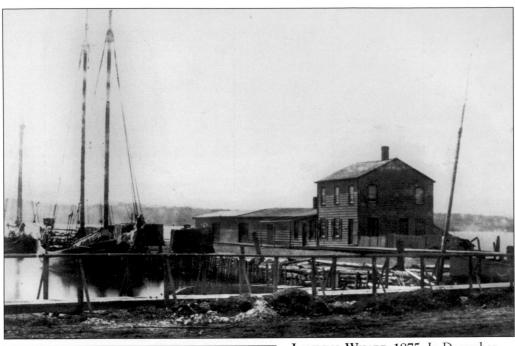

LANDING WHARF, 1875. In December 1828, William Weeks and a group of interested parties founded a stock company for the building of a wharf at Cape Breton. By July 1829, the steamboat *Linnaeus*, captained by Elijah Peck, made daily stops at the dock. The area came to be known as the Landing.

GLEN COVE, 1856. From 1854 to 1856, the side-wheeler *Glen Cove* made two daily round-trips between Glen Cove and New York. The route was not economically viable, and the boat was sold. Fitted out with a steam calliope, she plied the waters of the Hudson and later burned during the Civil War. American maritime painter James Bard immortalized both the *Glen Cove* and the *Seawanhaka*.

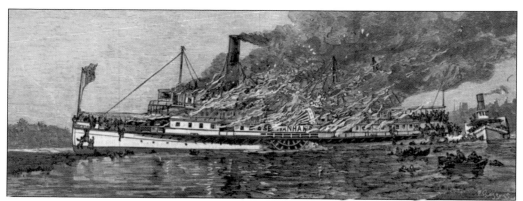

SEAWANHAKA, **1880.** On June 28, 1880, the fastest, most beautiful side-wheeler in the world exploded and burst into flame off Blackwell's Island on its return trip to Glen Cove. Three dozen lives were lost, and many were injured. Among the survivors were prominent Glen Covers Charles Dana, S. L. M. Barlow, Col. George Duryea, and his father, Hendrik V. Duryea. *Harper's Weekly* recorded the story in detail.

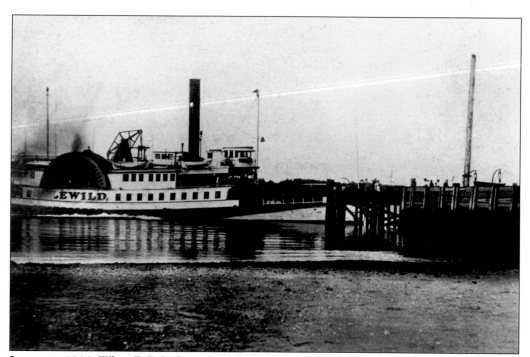

IDLEWILD, **1900.** When E. R. Ladew owned the steamboat wharf, the steamer *Idlewild* was permitted to take passengers to and from the Landing's dock. Ladew, however, refused to allow Sunday excursionists to come ashore. Senator James Norton, who owned a local hotel and profited from day-trippers, led a fight for a public dock to be built. Wealthy landowners defeated the plan.

APPLEBY'S BLUFF, 1900. From the site of the Hempstead Harbour Club, looking north, the clay bluffs of Garvies Point define the landscape. The club, located on the Appleby (formerly Garvie) property, was founded in 1891. (Courtesy of Frank Uhlendorf.)

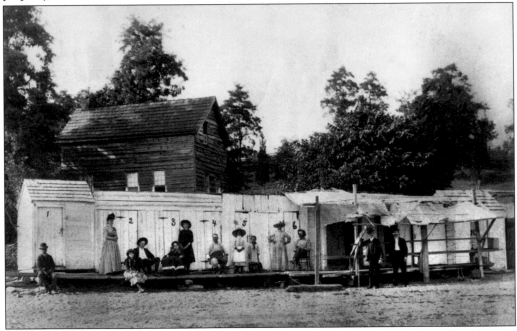

GARVIES POINT BATHHOUSES, 1899. Bathers owned their own individual dressing rooms. Bathhouses, built as needed, cost $25 to construct and $1 a year for maintenance. After a fire destroyed the changing rooms, they were never rebuilt.

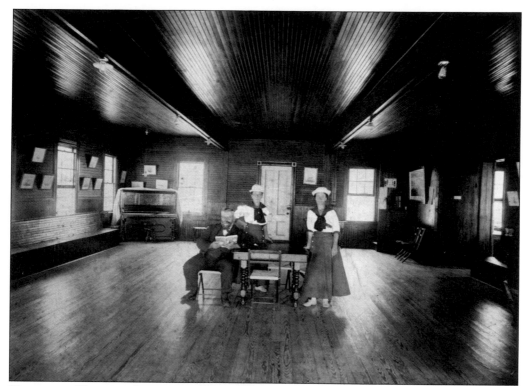

HEMPSTEAD HARBOUR CLUB, 1899. The Miller sisters, Cap'n Mame (left) and Cap'n El, seen here with Elwood Valentine (seated), were stewards of the Hempstead Harbour Club from the early 1900s until Mame's death in 1936. As daughters of the first club steward, they were so respected for their skill in maintaining boats and hauling engines that J. P. Morgan lent them the *Opal*, his Glen Cove Jewel-class racing boat. (Courtesy of Edna Dorfman Freeman.)

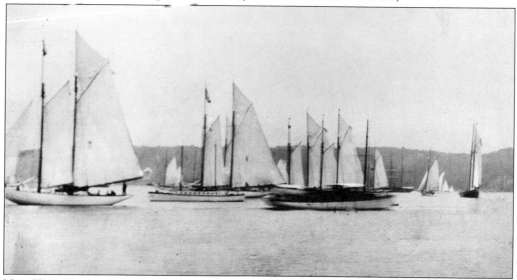

NEW YORK YACHT CLUB ANNUAL CRUISE, 1910. The New York Yacht Club's yearly rendezvous inside the breakwater at Hempstead Harbor, followed by a dinner dance at the Pavilion Hotel, was the highlight of the blue-blood social season. (Courtesy of Frank Uhlendorf.)

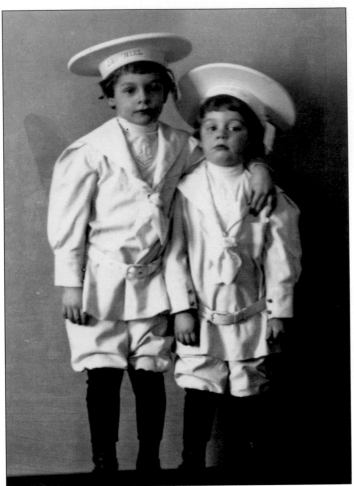

YOUNG SAILORS, 1908. George DuPont Pratt Jr. (left) and Sherman Pratt, the sons of George DuPont Pratt, stand dressed for an outing in their sailor suits. Their hats bear the label *Jathaniel*, the name of their uncle Charles Millard Pratt's yacht. (Courtesy of North Shore Historical Museum.)

THE MERMAID, 1930. The *Mermaid* was the tender for J. P. Morgan's *Corsair*. Besides the great steam yachts, many wealthy estate owners had smaller steam launches that they used for the commute to their offices on Wall Street and also a ship's tender to transport passengers and supplies to the larger vessels. (Courtesy of Walter Paddison.)

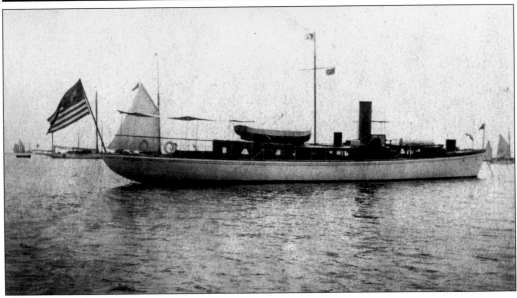

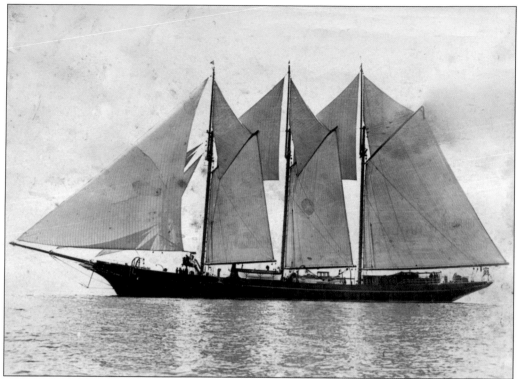

HUSSAR I, 1923. Designed by Cox and Stevens, the *Hussar* was built in 1923 for E. F. Hutton. In 1934, he had this 585-ton iron-hulled luxury yacht replaced with an even larger ship, the *Hussar II*. When he married Marjorie Merriweather Post, that ship was renamed the *Sea Cloud* at her request. It was the largest ship ever to sail the local waters. (Courtesy of Frank Uhlendorf.)

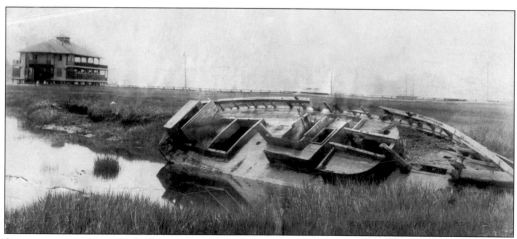

SHIPWRECK, 1928. Old hulks past repair were sometimes left to rot in and on the banks of the creek. Before its restructuring in the 1930s, Glen Cove Creek meandered around Cedar Island and other marshy areas. Harbor Beach Pavilion can be seen in the background. (Courtesy of Frank Uhlendorf.)

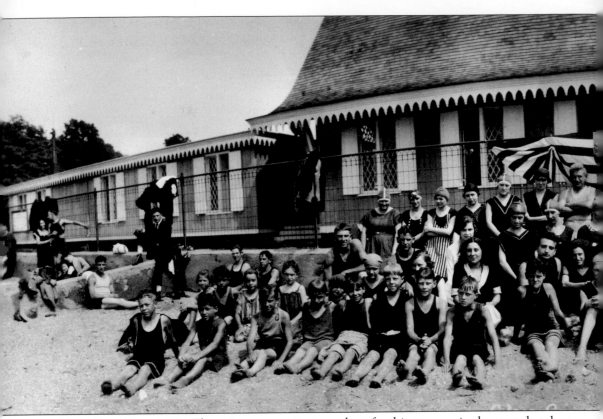

GLEN COVE DIPS, 1929. The swim community turned out for this panoramic photograph, taken in front of Yacht Station No. 10. In 1904, the yacht station, of the famed New York Yacht Club, was brought by barge from Elysian Fields, New Jersey, and located south of the Landing's wharf.

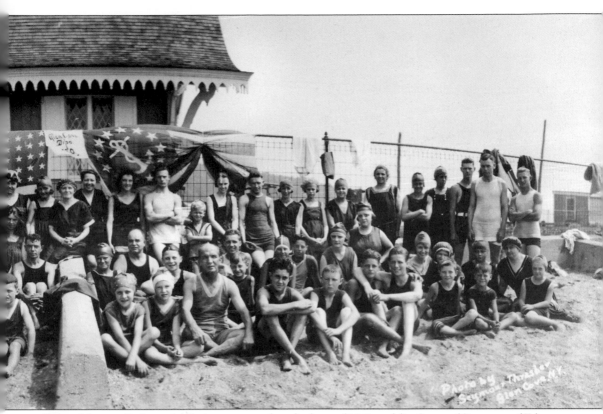

When Morgan Park was built, it was moved to the base of McLoughlin Street. (Courtesy of Edna Patrick Shotwell.)

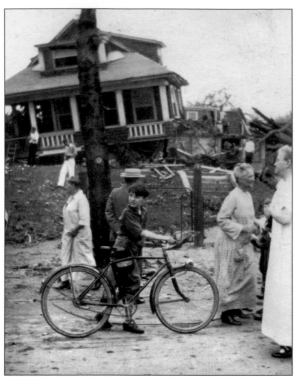

AFTER THE WATERSPOUT, 1926. The waterspout of 1926 came across the harbor, slammed into Front Street (now Shore Road), knocked houses off their foundations, tore up roofs, and shredded camp tents. Reportedly the crew of J. P. Morgan's *Corsair* fired a small salute cannon into the twister in a vain attempt to dispel it. (Courtesy of Edna Patrick Shotwell.)

MACKEREL CATCH, 1930. The waters of Long Island Sound once teemed with mackerel and other sea life. When anglers returned to the Landing's fishing station with their catch, Nellie Patrick immortalized them with her camera. Her daughter, Edna, often posed in front to add interest to the image. (Courtesy of Edna Patrick Shotwell.)

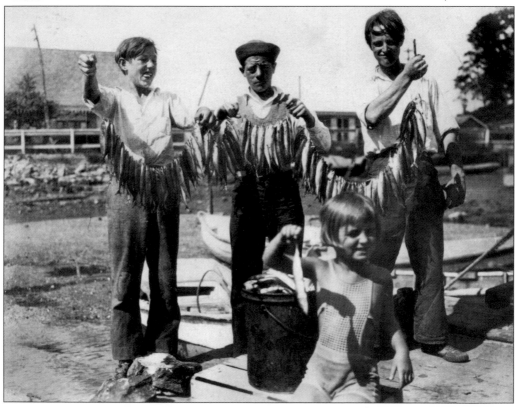

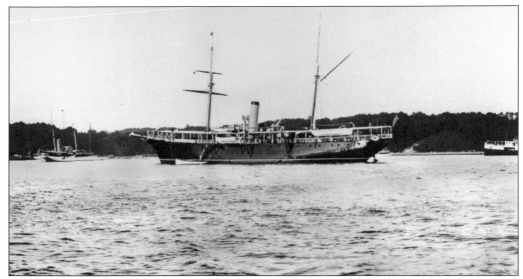

CORSAIR, 1905. J. P. Morgan Jr.'s yacht *Corsair* could be seen off Matinicock Point or in the harbor just beyond Yacht Station No. 10. Morgan inherited *Corsair III* at his father's death in 1913. *Corsair IV*, launched in 1930 in Bath, Maine, as the country's economy collapsed, was 343 feet long and cost $2.5 million to build. (Courtesy of Sea Cliff Village Museum.)

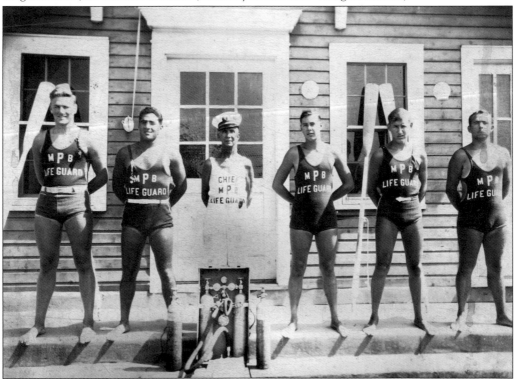

MORGAN PARK BEACH LIFEGUARDS, 1941. From left to right, Lenny Cocks, S. Simoneschi, W. R. "Pop" Kinnear, Jack Darby, B. Hill, and William Beglin were the Morgan Park lifeguard crew on July 10, 1941. Anne Stumph took over from Kinnear as chief lifeguard during the war years. (Courtesy of Linda Darby.)

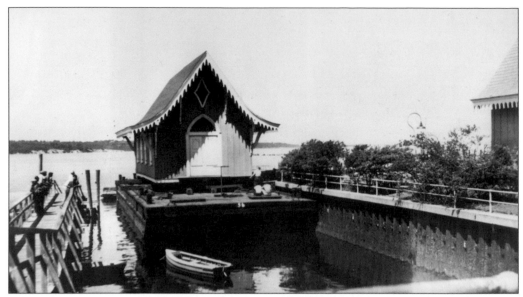

YACHT STATION No. 10, 1949. When New York Yacht Club closed the Glen Cove–based station, the building was transported by barge from its location at the foot of McLoughlin Street to Mystic Seaport. It was later moved again to Newport, Rhode Island. This gingerbread clubhouse, which survived five moves, remains intact today.

AMERICAS' SAIL '98. The Americas' Sail '98 visit to Glen Cove brought 13 tall ships, including the three-masted barque *Libertad* from Argentina and the *Kalmar Nyckel*, a replica of a Swedish man-of-war. The celebration, hosted by the city and the Glen Cove Yacht Club, brought 350,000 people to the shorefront. The Glen Cove Yacht Club celebrated its 50th anniversary in 2010. (Courtesy of Marguerite Suozzi.)

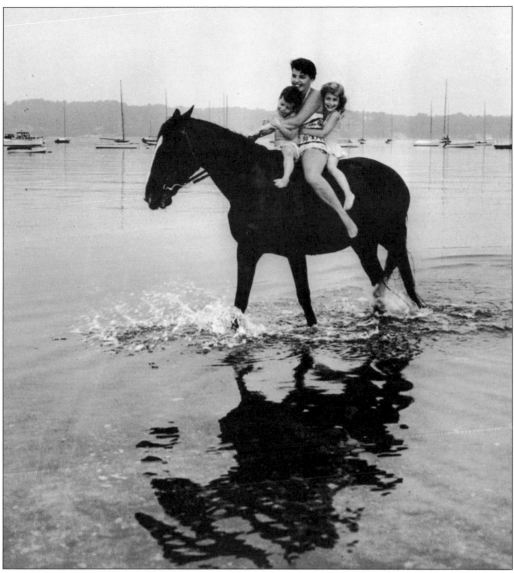

Domino, 1957. Edna Dorfman and her children, David and Lisa, enjoy a cooling ride in Hempstead Harbor. Domino, a horse who loved to swim, once soaked a brand new bridle and saddle. The Dorfman children enjoyed riding him to Landing School from their nearby home on the Dickson estate as schoolmates eagerly awaited their arrival. (Courtesy of Edna Dorfman Freeman.)

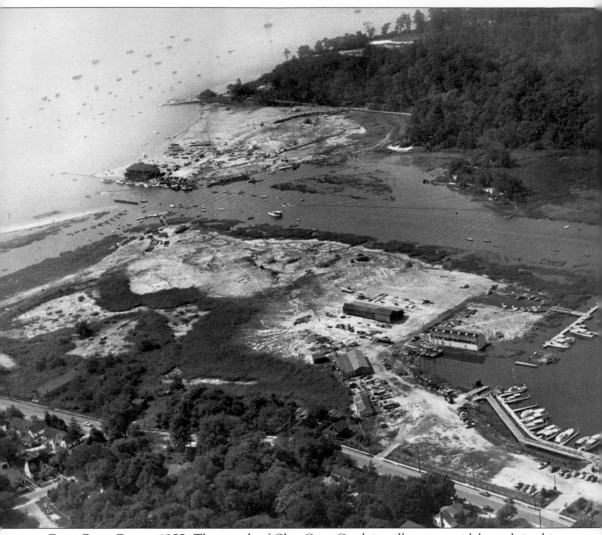

GLEN COVE CREEK, 1955. The mouth of Glen Cove Creek is still an open tidal marsh in this mid-20th-century photograph by Vincent. The area, since remediated and filled in, is now slated for a high-rise luxury development that, if built, will change the rural character of the waterfront. (Courtesy of Frank Uhlendorf.)

Three

HOTELS AND
PUBLIC HOUSES

Hempstead Harbor became a destination in 1835 when the Pavilion Hotel opened to lodge visitors arriving by steamboat. The establishment became a popular resort, providing country respite for society folk, theatrical personalities, and soldiers convalescing from the Civil War. Located a short but picturesque boat ride from Manhattan, the Pavilion grew into an elegant hostelry accommodating 300 guests.

Inns and boardinghouses for those of lesser means opened around Landing Road, then called Main Street. These included Andrew Wilson's Valentine Hotel, ex-senator James Norton's American House, E. M. Underhill's Landing Hotel, and the Belvedere. Many still stand, albeit in much altered form, as multifamily dwellings.

In June 1865, an excursion of Eastern District firemen came in by boat and tore up the Landing in a quest for "liquor and segars." A riot ensued, with orchards raided, houses invaded, and a brawl in Hoskins's barroom. The incident tripped off a 50-year-long controversy involving temperance groups, underwater rights, and docking privileges.

In 1880, the Pavilion burned to the ground in a spectacular midday conflagration, leaving only the ballroom wing standing. Under the ownership of leather baron E. R. Ladew, this building was joined to Glendale and became the Hall. It was a successful boardinghouse until its demolition for the creation of Morgan Park.

In the village, there were numerous rooms available. Harrold's House is remembered for an incident in which its upper piazza collapsed, dropping 60 people viewing a tableaux vivant several stories to the ground. Fred Stroppel's Depot Hotel was the favored place to find refreshment on arrival at Glen Street Station, and in the village, there was Glen Cove Hotel, Schleicher's, and the Oriental at the corner of Glen and School Streets.

Joseph Roll's Oriental, with its own stable, saloon, and brokerage house, was an establishment of note. Unfortunately Prohibition put an end to its profitability, and the building was lowered to one story.

Today the former John Teele Pratt Manor House in Dosoris, now the Glen Cove Mansion and Conference Center, serves visitors seeking elegant accommodations.

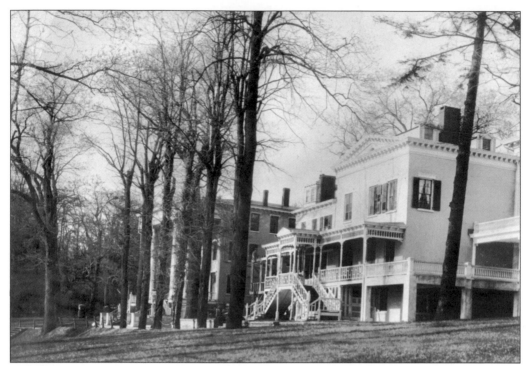

THE HALL, 1895. The Pavilion Hotel was the first of many great seasonal hotels on the North Shore. After it burned in 1880, the ballroom wing was the only part left standing. It was incorporated into the Hall, an equally successful resort that stood until the building of Morgan Park.

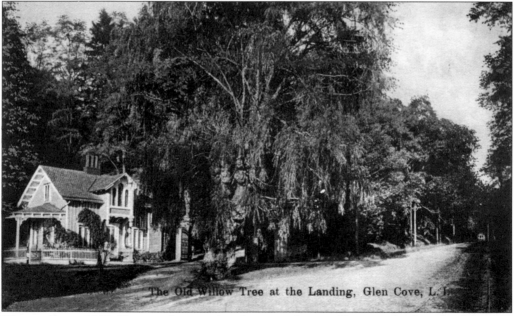

The Old Willow Tree at the Landing, Glen Cove, L. I.

WILLOW TREE, 1910. Few people remember the magnificent willow trees by the side of the road where the entrance to Morgan Park is today. Willows were once common in the city, when the water table was higher. In the distance, a trolley can be seen making the last leg of its journey to the dock.

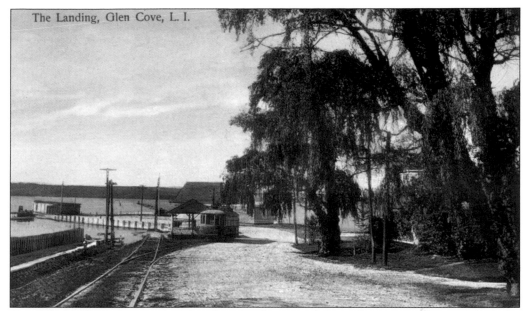

The Landing, Glen Cove, L. I.

TROLLEY AT THE LANDING, 1908. Landing Road, previously Main Street, actually ran right to the dock. Stories are told of trolleys overrunning the track and cars braking too slowly and ending up in the harbor. When Morgan Park was built, the road was terminated in a fenced dead end that parallels the pedestrian entrance.

THE HALL IN THE SNOW, 1930. This picture was taken the last winter the Hall stood, before the creation of Morgan Park. The Ladew family owned this popular resort, which had been fabricated from the ballroom wing of the old Pavilion and Glendale, a building that combined the former Weeks and Luyster homes. (Courtesy of Edna Patrick Shotwell.)

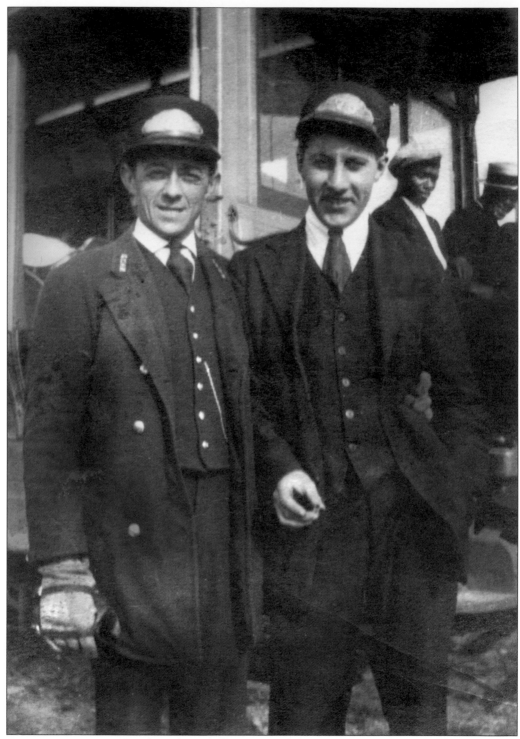

TROLLEY MEN, 1918. Frank Lockwood (left) and George Duryea, the first and last motormen on the Glen Cove Trolley, wait for fares. The trolley made 42 twenty-minute trips on weekdays from Sea Cliff Station to the Landing's dock and back. (Courtesy of Joseph Cunningham.)

INVINCIBLE WHISKEY. This bottle of evaporated spirits from the Belvedere Hotel was found in the wall of a building being renovated on Carpenter Street in 2007. It bears the name of John J. Buckley, an early proprietor. (Courtesy of Skip Losee.)

BELVEDERE HOTEL, 1908. William Spennecke, father of the World War I soldier who posed for the Doughboy Monument, was another proprietor of this "gentlemen only" establishment. Located on John Street in the Landing, the Belvedere was the last stop for the trolley before it made its way to the dock. In later years, the Belvederes ball team counted members of the Doxey, Cock, and McDougal families among its players.

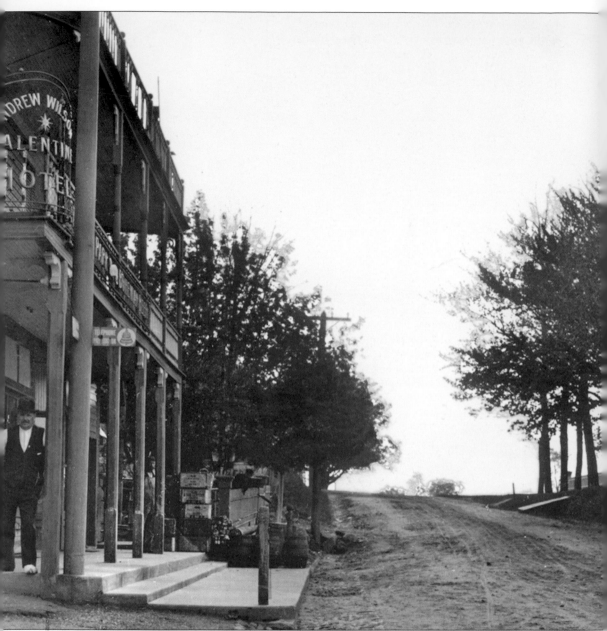

VALENTINE HOTEL, 1905. Proprietor Andrew "Shanghai" Wilson stands on the steps of his hotel at the corner of Valentine and Carpenter Streets. This building, minus its balconies, held Ralph's Store for many years. During this era, an upstairs bedroom was reputedly haunted by the presence of Wilson, an "old salt," who had once been first mate on a Finnish sailing ship. (Courtesy of Ralph Cioffi.)

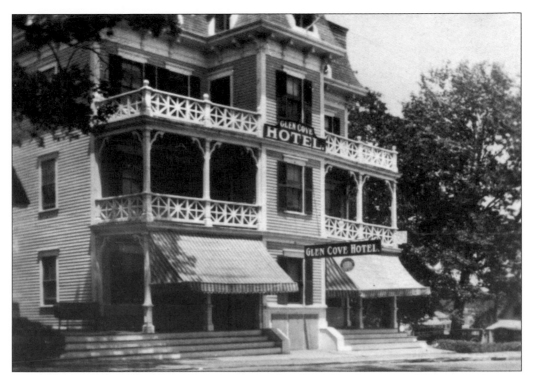

HOTEL IN THE LANDING, 1930. This charming Glen Cove Hotel was one of the many places to stay located in close proximity to the Landing. The charming balconies and awnings made it most inviting to arriving visitors. (Courtesy of Edna Patrick Shotwell.)

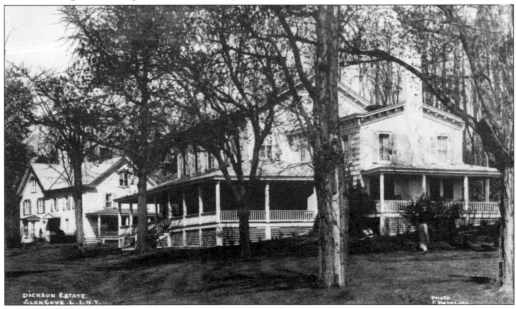

DICKSON ESTATE, 1900. Daniel Coles built the elegant old home, shown in this photograph by F. Dowling, before 1692. In the 1890s, under the ownership of Sidney and Mary Whitson, it was a theatrical boardinghouse where Lillian Russell stayed. It was razed for the building of Janet Lane. (Courtesy of Edna Dorfman Freeman.)

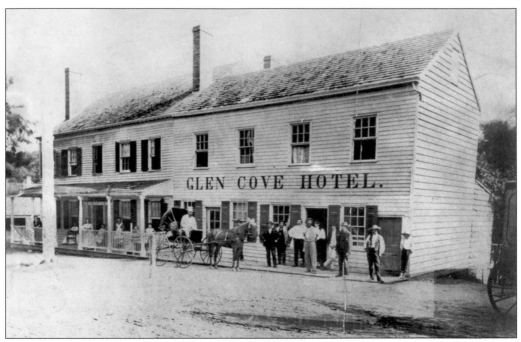

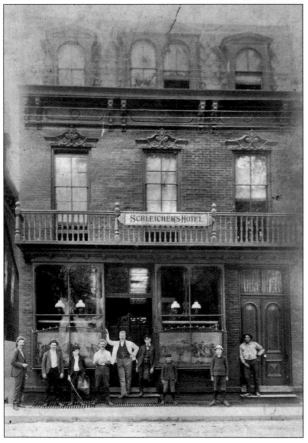

GLEN COVE HOTEL, 1889. This establishment, run by William Green, stood on Glen Street near where the bridge over the lower lake entered town. It was opposite the home of Dr. George Alt-Muller, which later became the site of the Oriental Hotel and the bank buildings. The hotel was eventually repurposed into Schwab's bakery.

SCHLEICHER'S HOTEL, 1890. In 1877, Frederick Schleicher was the proprietor of the Glen Cove Hotel. He then opened his own establishment, which was the starting point for horse-drawn sleigh races to Glen Street Station. Glen Street, a rutted dirt road, was eventually curbed and paved to keep down the dust and improve transit.

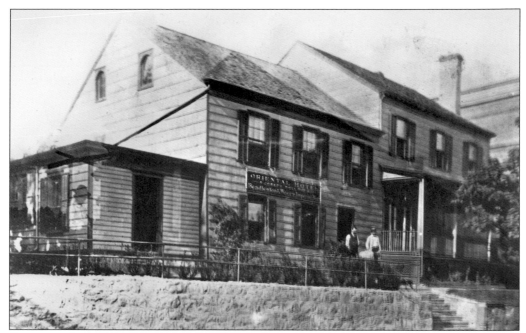

ORIGINAL ORIENTAL HOTEL, 1898. This photograph reveals that Joseph Roll's first Oriental Hotel was a large house made over to accommodate travelers. The sign on the front advertises Beadleston and Woerz Imperial Beer. Early maps of the city show this property to have originally been the home of Dr. George Alt-Muller, a distinguished German-born physician and surgeon.

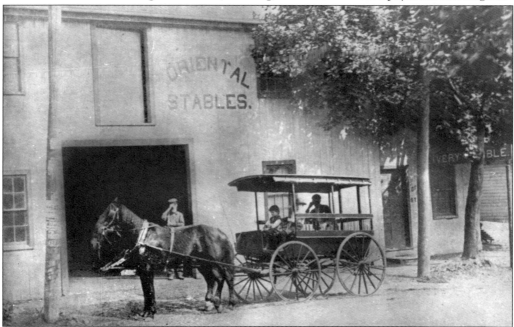

ORIENTAL STABLES, 1900. The Oriental stables, just around the corner from the hotel on School Street, tended the horses and carriages of hotel guests and rented out transportation as needed. The distinctive tower of the building, once a firehouse, can be seen in early photographs of the city taken from Mill Hill.

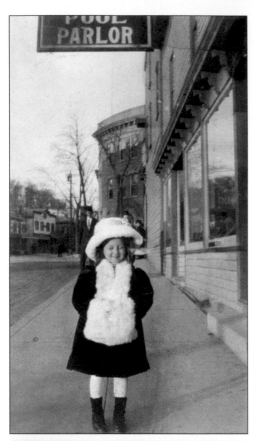

POOL PARLOR, 1905. A young girl with her muff, dressed in the height of fashion, stands on Glen Street under the sign for the local pool hall. The curve of the front of the Oriental Hotel can be seen immediately behind her.

ORIENTAL HOTEL, 1915. The Oriental Hotel was reportedly a favorite stop for Theodore Roosevelt when he came to town from the summer White House in Oyster Bay. It had a grill, banquet rooms, and a brokerage house on the first floor where guests could check their investments. The Oriental fell on hard times during Prohibition and was renamed the Ambassador.

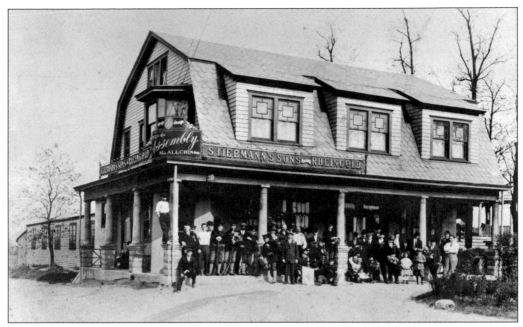

ASSEMBLY HOTEL, 1910. Located by Hazel and Carney Streets, the Assembly Hotel was a popular hostelry and watering hole. The 1920 census lists Albert Allchin, 43, as hotelkeeper and his wife as Mary, age 37. Their children, Albert and Mary, were 19 and 12 years old, respectively, at the time. The earlier generation of Allchins were emigrants from Great Britain. (Courtesy of the Allchin family.)

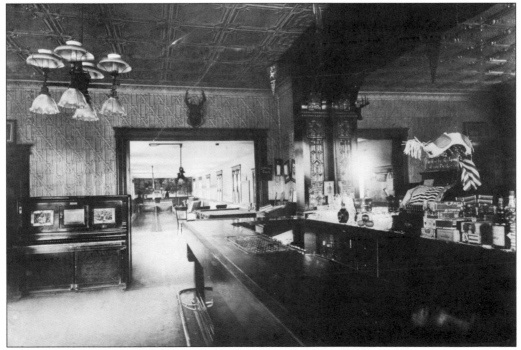

INTERIOR, ASSEMBLY HOTEL, 1910. The elegant interior of the Assembly Hotel was outfitted with a capacious bar and a good-size bowling alley. (Courtesy of the Allchin family.)

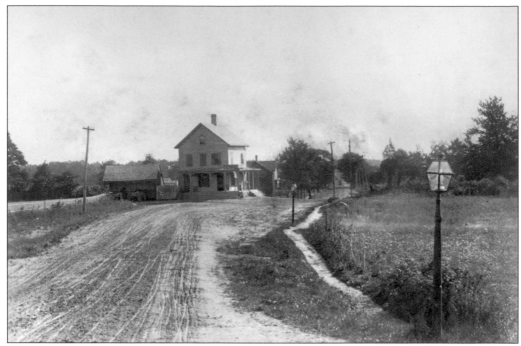

HALFWAY HOUSE, 1885. Visitors arrived by wagon at the Halfway House before the coming of the trolley, and the old wagon sheds can be seen to the left of the building. Located on the corner of Sea Cliff Avenue and Backroad Hill, it was replaced by the Colony Hotel in 1890.

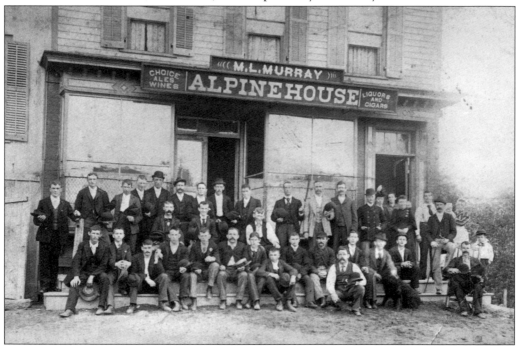

ALPINE HOUSE, 1912. This popular public house was better known as Murray's Bar and Grill. It was located on Backroad Hill on Glen Cove Avenue opposite the Cement Works and Woods Market, near Cecil Avenue.

Four

INDUSTRIES AND RURAL LIFE

Joseph Carpenter built a sawmill at Musketa Cove in 1668. Grist and fulling mills followed. A tidal mill was built in Dosoris. Clay deposits discovered by the Carpenters south of the creek and later at Sheeps Pen Point by Dr. Thomas Garvie led to the building of wharves for the shipment of raw materials and brick.

In the 1850s, the Duryea starch works opened on the southern banks of the creek. It grew into a Goliath employing more than 600 workers, and its corn-based products won fame at international expositions. The starch works had its own box factory, a company newspaper, and a fleet named after the seven Duryea sons. Atwater Benham and Company, a tin and ironware manufactory located on Glen Street, employed more than 100 workers.

In 1903, the starch works closed due to economic factors, and it was consumed by flames three years later. On the north bank of the creek, Ladew Leather Company filled the economic void. Thousands of hides a year were processed into belts that ran the machinery that turned the wheels of 19th-century America. Columbia Carbon and Ribbon and Powers Chemco, then Konica Minolta, occupied this site after the leatherworks closed. To the west, Wah Chang (Great Development) Trading Company was founded by Kuo Ching Li and evolved into Li Tungsten, the largest refinery of its kind in the world.

In 1953, a Glen Cove Industrial Exposition was held at the Sons of Italy Hall celebrating local industry. A second major industrial area developed on the southern border of the city that included Photo Circuits, Slater Electric, and Zoomar, where Dr. Frank Back oversaw the development and production of the first zoom lenses.

Quaker-owned farms bordered the city, and an abundance of estate and backyard farms were scattered throughout, with asparagus being a major crop. Many families had their own cows, and milk from the heights above the back road was so rich the area was called Cream Pot Hill. The simultaneously industrial and rural character of the city lasted until the suburbanizing housing boom following World War II.

DOSORIS, 1899. Robert Kohler, "nimrod," stands on the stump of one of five massive buttonball trees that stood around the duck pond in old Dosoris. The farmhouse in back housed Henry Tone and his very old mother, guardians of the Latting properties, where asparagus was grown.

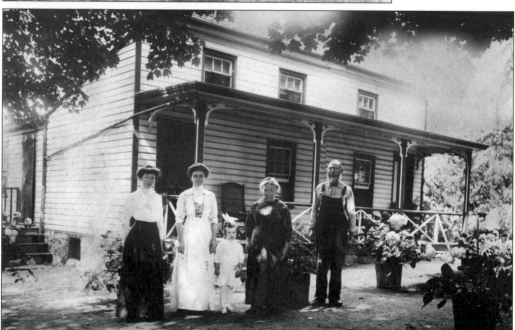

CONWAY FAMILY FARM, 1914. John Conway's 4-acre family farm on Elm Avenue had a barn, a farmhouse, and 15 cows. John came from Ireland in 1874 and became a citizen of Queens County. Michael J. Donohue photographed the Conways in front of their home. From left to right are Sara, Delia, Irma, Jane, and John Conway. (Courtesy of Herbert Conway.)

PRICE FARM, DOSORIS, 1918. H. K. Vail, son-in-law of Mrs. G. J. Price, tends Roger the pig, who exchanges sniffs with Shamus the Airedale. The Price farmhouse was the original homestead of Rev. Benjamin Woolsey and his wife, Abigail Taylor, who inherited Dosoris from her father. Dosoris comes from the Latin *Dos Uxoris*, meaning wife's dowry.

TITUS POND, 1905. The pond on the Titus farm was popular with cows in the summer and with ice-skaters in the winter. This large Quaker farm was northeast of downtown Glen Cove.

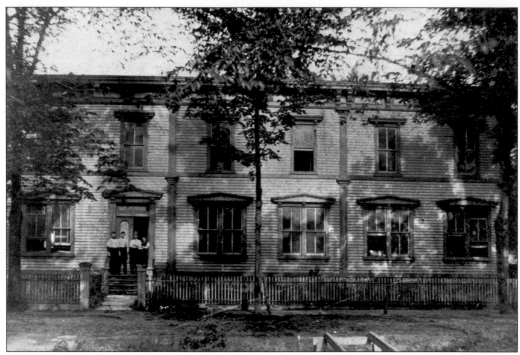

STARCH WORKS BUILDINGS, 1898. In addition to the factory itself, the starch works had numerous office buildings and provided work for peripheral trades throughout the city. Ludlam's blacksmith shop and carriage works on School Street tended the horses and wagons that continuously moved corn into the city and animal feed out to the area farms.

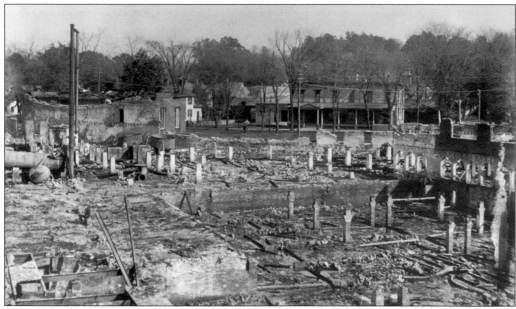

STARCH WORKS RUINS, 1906. The starch works, the first major manufacturing business in the city, was plagued by fires, with major ones occurring in the 1860s and again in 1897 and 1898, hastening the demise of the business. In 1903, the plant closed permanently. The empty facility was completely consumed by fire in 1906.

SAND PIT, SOUTH GLEN COVE, 1900. Clay was found on Joseph Carpenter's property in South Glen Cove about 1827. Carpenter began the manufacture of firebrick, and three large docks were built to transport the wares. Two were in Glen Cove Creek, and the third, at Rum Point, became the Sea Cliff steamboat dock. (Courtesy of Sea Cliff Village Museum.)

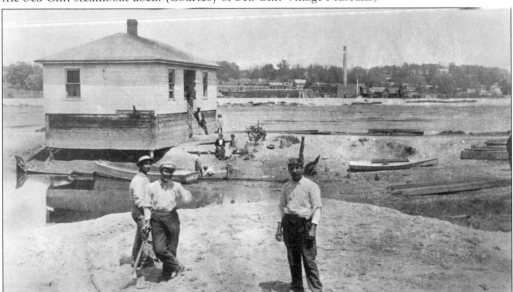

CREEK VIEW, 1907. The meandering creek through Musketa Cove was industrialized with the opening of the Duryea starch works in the 1850s. As early as 1884, there were complaints about pollution in the creek and pleas for Gov. Grover Cleveland to shut the plant down. The creek bed was straightened, and the islands pictured were dredged out in the 1930s.

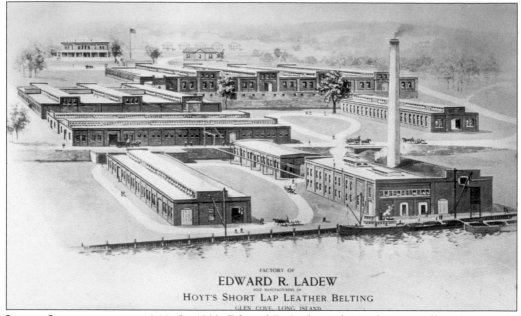

FACTORY OF
EDWARD R. LADEW
SOLE MANUFACTURERS OF
HOYT'S SHORT LAP LEATHER BELTING
GLEN COVE, LONG ISLAND

LADEW LEATHERWORKS, 1903. In 1893, Edward R. Ladew inherited a controlling interest in Fayerweather Ladew Belting Company. He bought the extravagant country estate Elsinore in Glen Cove and opened a branch factory at the head of the creek. With his brother Joseph, he joined other independent belting concerns to form the massive conglomerate U.S. Leather Company.

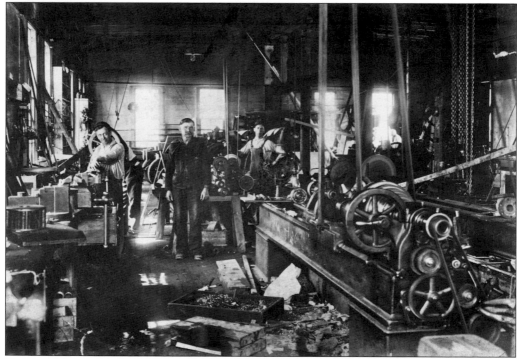

FACTORY INTERIOR, 1900. As business at the starch works diminished, work crews began to switch employment to the leather factory. This was accelerated by a series of fires in the late 1890s. At its height, the leatherworks employed 500 workers and processed 250,000 hides a year.

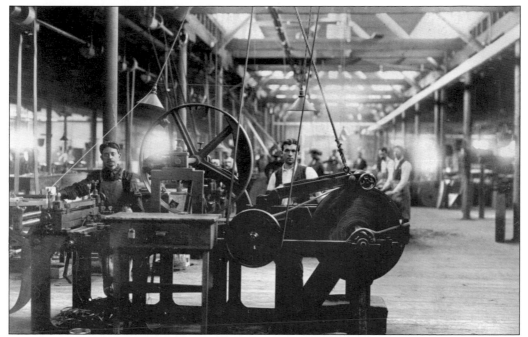

LEATHER WORKERS, 1900. The Ladew concerns were different from other belting works in that they tanned their own hides. During the Ladew period, Glen Cove was very much a company town, and the family was involved in all aspects of the work and social life of the village. Their sociability extended to their workers, and the entire factory attended the wedding of the Ladew daughter, Elise, to W. R. Grace in 1914.

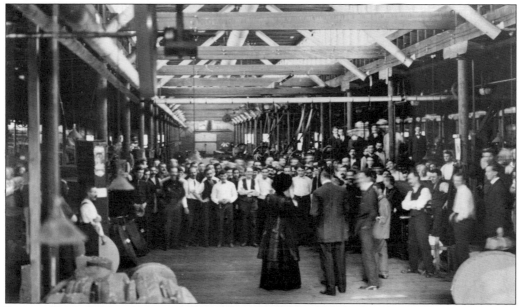

LOUISE "LULU" WALL LADEW. 1906. After the death of her husband in 1905, Louise Ladew proved herself an astute businesswoman. She enlarged the factory and built more than 100 workers' cottages. After her death in 1912, son Harvey decided it was much more fun to enjoy his fortune consorting with café society than to work. In 1927, the factory was sold at auction.

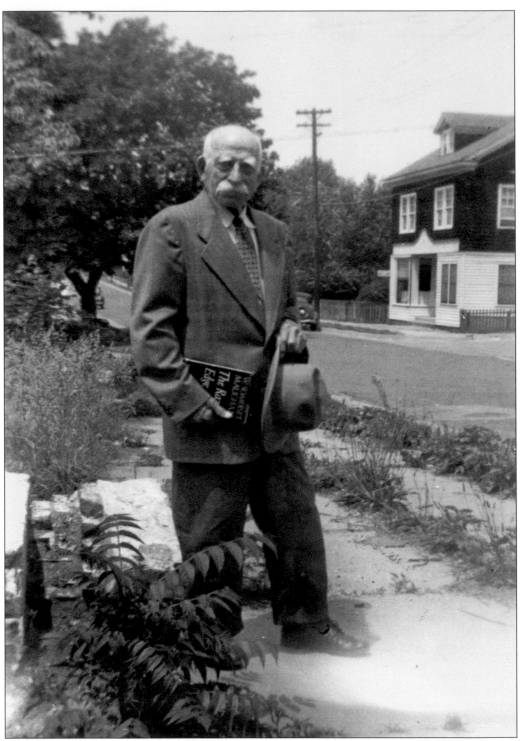

Chief Belt Inspector, 1955. Joseph H. Reynolds, chief belt inspector for E. R. Ladew, spent his later days at home in the Landing reading. He stands on Carpenter Street opposite the barbershop, a copy of Somerset Maugham's *The Razor's Edge* in hand. (Courtesy of Richard Reynolds.)

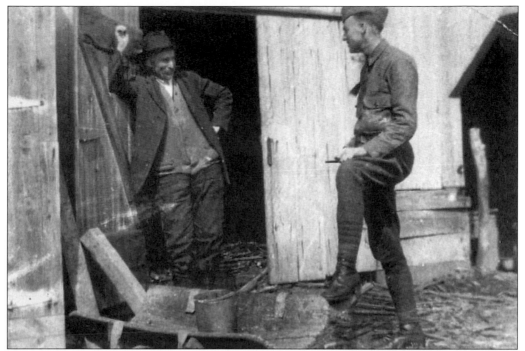

BOYD FARM, AFTER WORLD WAR I, 1918. Returning World War I veteran William Joseph Boyd, a member of the 105th Machine Gun Battalion, 26th Division, Company C, has a talk with his father, Francis Joseph Boyd, on the family farm near Elm Avenue and Frost Pond Road. (Courtesy of Shelia Boyd and Walter Zaikowski.)

ELM FARMS, 1936. In the 1930s, Conway farm was known as Elm Farms. In addition to milking cows and delivering milk, Herbert Conway cut corn for John H. Youngs's cows. Although the barn burned down long ago and the area is now Conway Court, the 160-year-old farmhouse is still inhabited. (Courtesy of Herbert Conway.)

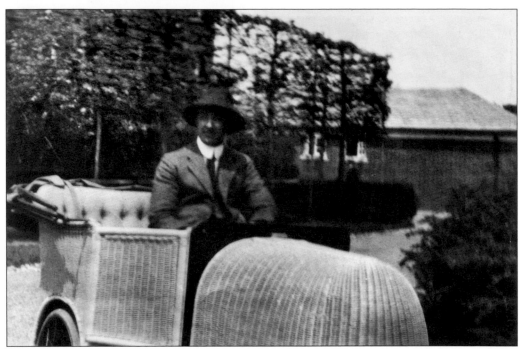

WICKER CAR, 1923. Walter J. Paddison, who was brought to America from Wales by J. P. Morgan Jr., chauffeured Jane Morgan for 25 years. Paddison was clever with mechanical things and invented this wicker car himself while working at Matinicock Point, the Morgan estate. (Courtesy of Walter Paddison Jr.)

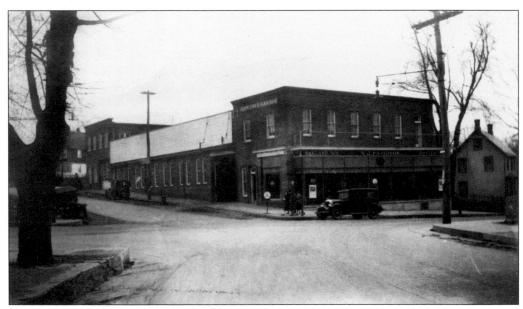

PADDISON MOTORS, 1928. Walter Paddison assisted in the preservation of J. P. Morgan Jr.'s life during an assassination attempt on July 4, 1915. In gratitude, Morgan arranged for Paddison to own a car dealership on School Street. For the past 25 years, the vintage building, constructed from starch work brick, has been the home of the Piano Exchange. (Courtesy of Walter Paddison Jr.)

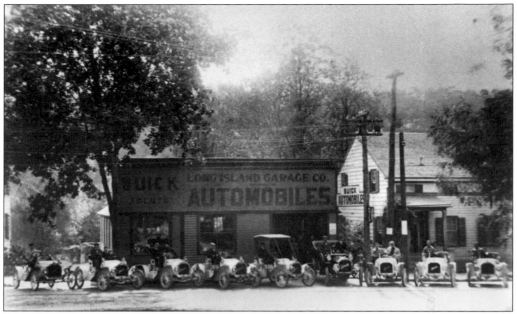

LONG ISLAND GARAGE COMPANY, 1920. This early Buick dealership on Glen Street was well known for selling quality "speed buggys." It became Seaman's garage and for the past 30 years has been the North Coast Subaru Dealership, a family-owned business.

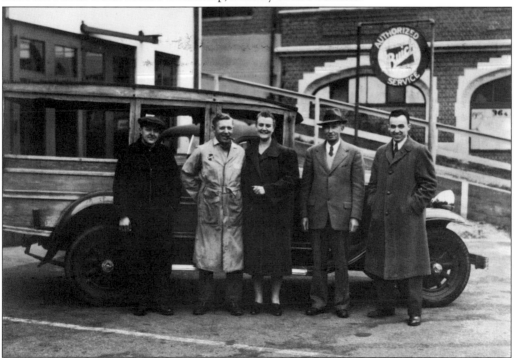

SEAMAN MOTOR CAR COMPANY, 1943. This dealership, owned by Sam Seaman and family in the 1940s and 1950s, was one of several quality car emporiums on Glen Street. From left to right are mechanic Lou Kaminski, Jack Mulder, a Mrs. McGill, owner Sam Seaman, and salesman Tom Kearney. (Courtesy of Ellie Pucciariello.)

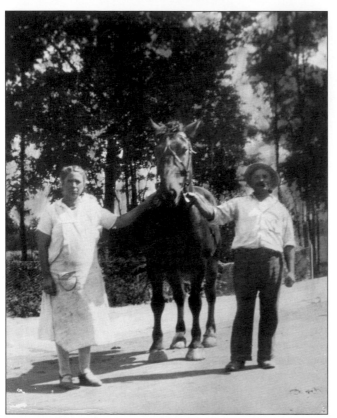

CHARLIE, 1935. Laura and Anthony Mercadante set out from their East Avenue home with Charlie, their horse. Anthony, originally from Sturno, Italy, worked excavating the ground for the building of both St. Patrick's and St. Rocco's Churches. Sadly Charlie was sold after machines took the place of horses. (Courtesy of Brian Mercadante.)

COAT FACTORY, 1945. Harry Slutsky's second-floor garment factory on the east side of School Street was a major employer of the women of the Orchard. The coat factory was just one of numerous textile-related business operating in the city. (Courtesy of Jerry Di Blasio.)

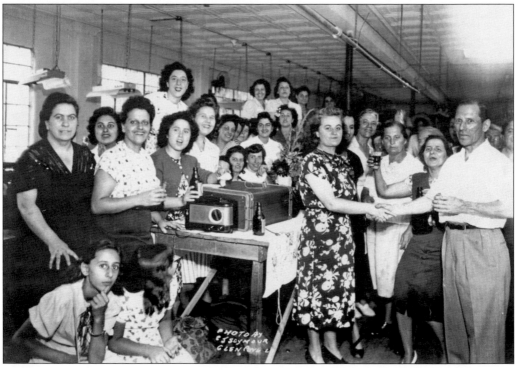

CARRIAGE RIDE, 1942. James D. Neillands, who was employed by the Pratt family, arranged for children of his estate worker friends to ride the ponies and go for carriage rides around Pratt Oval. The oval became a small industrial park where footlockers and later Mary Chess Fragrances were made. (Courtesy of Barbara Holzkamp.)

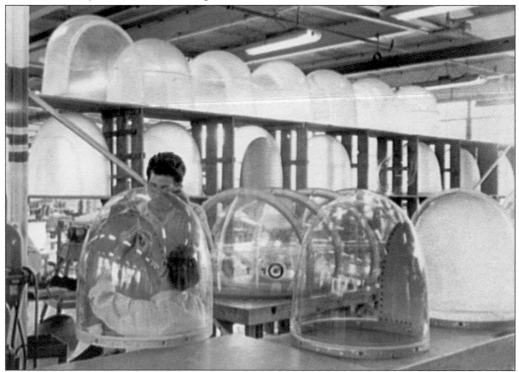

STEINER PLASTICS MANUFACTURING COMPANY, INC., 1953. Steiner Plastics manufactured Plexiglas jet cockpit canopies at Pratt Oval for Grumman Aircraft Engineering Corporation. The business closed when a scheme was discovered to ship substandard canopies without proper inspection by switching approval stamps and serial numbers. (Courtesy of the Gottscho-Schleisner Collection, Library of Congress.)

COLUMBIA CARBON AND RIBBON MANUFACTURING COMPANY. Collectibles on eBay and carbon residue are all that are left of this leading manufacturer of carbon paper, typewriter ribbons, and duplicating and processing machine supplies that came to Glen Cove in 1929. It is said that on a snowy day one could follow the carbon-blue footprints of the homeward-bound workers from the creek-front plant to their neighborhoods.

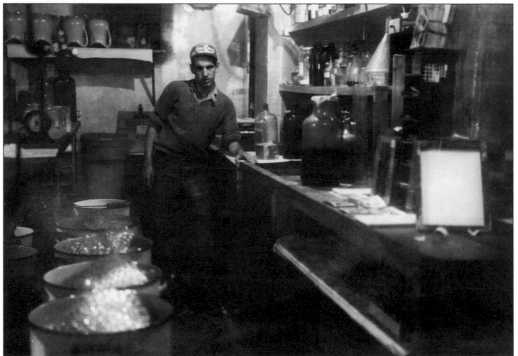

POWERS CHEMCO, 1945. This manufacturer and supplier of film, chemicals, and cameras to the graphic arts industry was also a leader in x-ray technology. Chemco was considered a defense-related industry during World War II, and Iver "Swede" Anderson, who made surveillance film emulsion, was exempt from military service. (Courtesy of Barbara Holzkamp.)

64

THE FAMILY COW, 1932. Many local families had a single cow to provide milk for the family. "Pa" Leosheski and his family lived by Glen Cove Creek on Herbhill Road, where the cement works is presently located. Glen Cove's side-by-side rural and industrial mixed neighborhoods lasted right up until the final days of the local industries at the beginning of the 21st century. (Courtesy of Ron Oldenburg.)

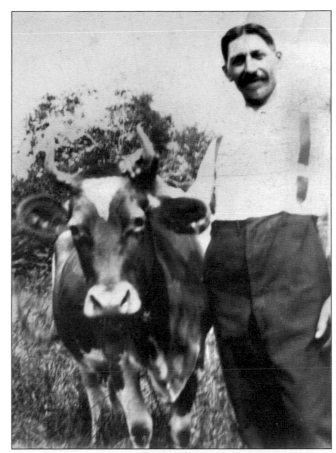

LI TUNGSTEN, 1965. Wah Chang/Li Tungsten Smelting and Refining, on the left in the aerial view below, was the world's largest tungsten and molybdenum separation and reduction facility. The factory supplied 90 percent of the Allies' tungsten during World War II. The property became a Superfund site, and the stack was blown up on Earth Day, April 22, 1998, as a symbol of renewal and revitalization.

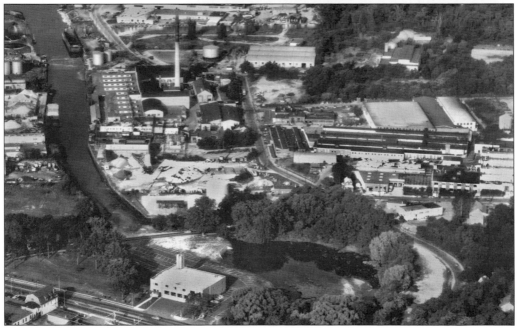

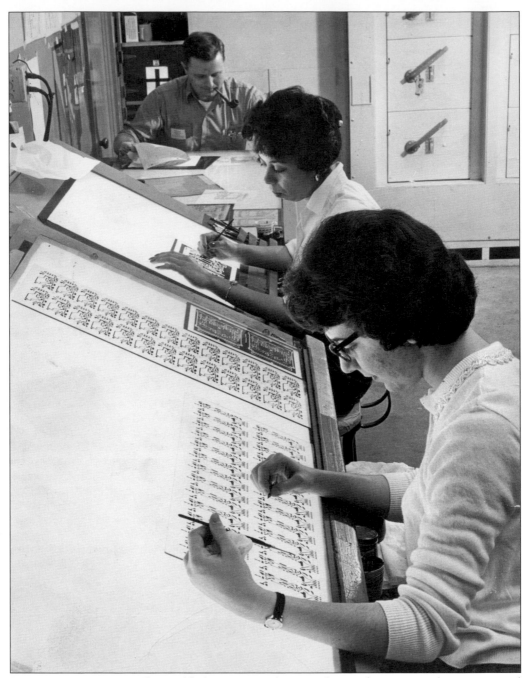

PHOTOCIRCUITS, 1959. The world's largest manufacturer of printed circuits used in commercial and military electronic systems began in the basement of Powers Chemco and moved to its own Sea Cliff Avenue facility in 1955. The last great city factory, Photo Circuits, closed its doors in 2007. Mary Jo Colangelo (foreground) and Mercedes Morales painstakingly retouch photo circuits while supervisor Bob Johanson looks on. (Courtesy of Mercedes Morales.)

Five

THE GREAT ESTATES

In July 1855, W. E. Burton, Esq., the 19th-century actor who built his country house above the Landing, enticed members of the New York Yacht Club to rendezvous in the cove. After sailing for prizes, a grand ball was held at the Pavilion Hotel, and the nascent Gold Coast was launched. After Burton's death, the house was redesigned by British architect Jacob Wrey Mould as the Glen Chalet.

The third owner, S. L. M. Barlow renamed this Victorian confection Elsinore. Enlarged and repainted, it became the showplace of the fourth owner, leather baron E. R. Ladew. The equestrian, horticultural, and yachting triumphs of his society family were recorded in the pages of the *Brooklyn Daily Eagle*. Other wealthy Brooklynites colonized the Red Spring and North Country areas.

Charles Dana, editor of the *New York Sun*, purchased West Island for his country estate. Later this horticultural paradise was given to Junius Morgan as a wedding present. He, in turn, built the spectacular Salutations, which still stands as the most private and opulent of the properties on the North Shore.

Charles Pratt, of Astral Oil, bought 1,000 acres of land and invited each of his eight children to build themselves country estates in Dosoris Park. Seamoor, Babbot House, Poplar Hill, Killenworth, the Braes (Webb Institute), and Welwyn were constructed as a result of his largesse. The Pratts employed 400 people and paid a quarter of Glen Cove's taxes. Farm produce, yacht voyages, and the run of the countryside were perquisites enjoyed by valued employees of these great landowners.

Joseph DeLamar's Pembroke, with its private harbor, and five-and-dime magnate F. W. Woolworth's marble palace, Winfield Hall, were two other phenomenally extravagant properties. Best remembered, though, is Matinicock Point, the East Island home of J. P. Morgan Jr. and family. The city was thrown into deep mourning after Jane Norton Morgan died of sleeping sickness in 1925. Heart broken, J. P. Morgan bought 16 acres in the Landing, built Morgan Memorial Park in her memory, and leased it to the city for 999 years, to be enjoyed by the inhabitants of Glen Cove and Locust Valley.

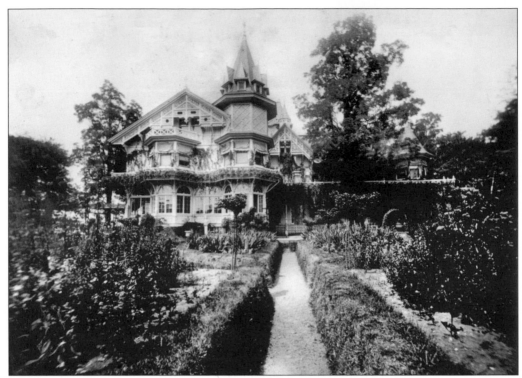

ELSINORE, 1905. After the death of W. E. Burton, a renowned theatrical figure and collector of Shakespeariana, his country seat passed to Thomas Kennard, then to railroad attorney S. L. M. Barlow, who called it Elsinore after his daughter Elsie. Leather baron E. R. Ladew and family, the final occupants, made Elsinore the showplace of the Gilded Age.

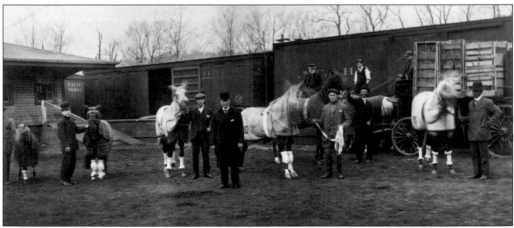

HORSES AND HANDLERS, 1900. Coachman Timothy Henkessey and stable hands care for prize horses at Glen Street. The Ladews' horses took first at the Queens County Fair, and Louise Ladew was one of the most accomplished horsewomen of her day. Elsinore horses had their names painted over the entrances to their stalls and on their bridles.

AFTER ELSINORE, 1938. After the demolition of the Elsinore mansion, developers built a large brick house for use as a model home. Although Waldo Hutchins, who grew up there, describes Elsinore as a country paradise, his childhood album evidences his fascination with the modern automobile. The Great Depression delayed development of Shorecrest for another dozen years. (Courtesy of Waldo Hutchins Jr.)

THE BIRCHES, 1930. Entrances to the large country properties were often gated and the entry roads flanked by long allées of trees. With sequential owners, estates were renamed to suit the fancy of the current inhabitants. (Courtesy of Ben Dunne and Brenda Dunne Brett.)

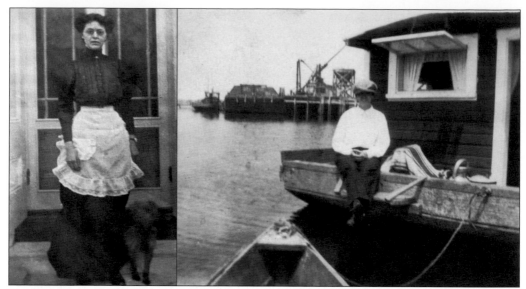

LADY'S MAID, 1925. Born in England, Louisa "Nellie" Patrick worked as a lady's maid on the Maxwell estate. She resigned her position to marry Lawrence Patrick, who left his job as a coachman on the Jacob estate to start his own boat-rental business. They lived in a houseboat off the Landing's dock with their daughter, Edna. (Courtesy of Edna Patrick Shotwell.)

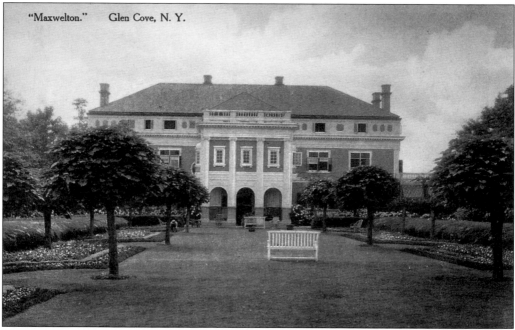

"Maxwelton." Glen Cove, N. Y.

MAXWELTON, 1912. John Rodgers Maxwell, cement baron and owner of the Long Island Rail Road, bought Weeks's farm to create his grand cottage. In 1950, the stone and marble domicile caught fire and was razed for the building of Whitney Circle. The water tower is now a wing of a contemporary house, and the development homes have interior and architectural details salvaged from the estate. (Courtesy of Peter Emmerich.)

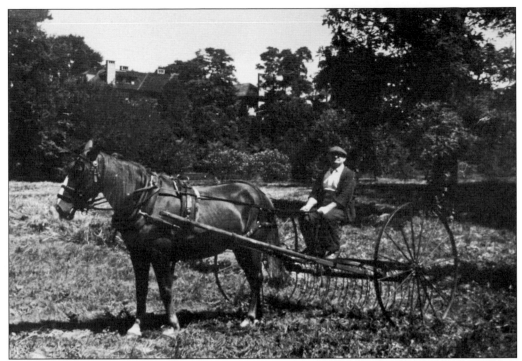

GROUNDSKEEPER, 1930. Joseph Gabrus, an emigrant from a large Polish family, kept the grounds of the Maxwell-Whitney estate compound that is now Whitney Circle. Here he is seen with his horse and farm equipment. (Courtesy of Sophie Luzynski.)

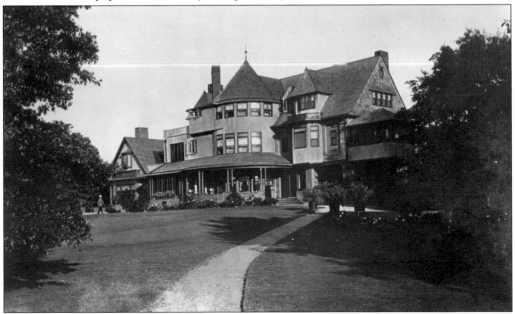

BUCKNALL ESTATE, 1935. G. Stafford Bucknall was an industrialist who built homes on St. Andrews Lane and in Red Spring Colony. The manor house at the end of Red Spring Lane is still extant but had its upper floor removed during the first quarter of the 20th century to lower the property taxes.

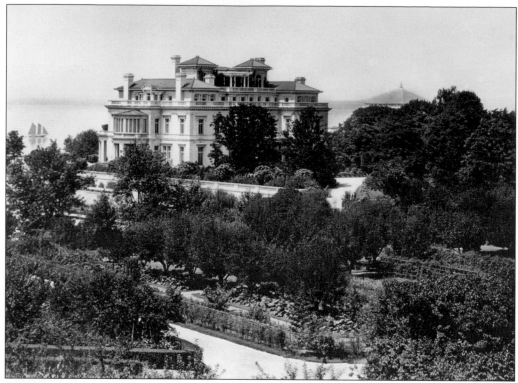

PEMBROKE, 1916. Capt. Joseph De Lamar built his Gold Coast palace at age 69 and died shortly after. The property had a 53-room French neoclassical mansion, a glass house, Japanese and formal gardens, a water tower, stables, and a private harbor for his steam yacht, the *May*. Later the estate was the scene of legendary parties when theater and film impresarios Marcus Loew and Arthur M. Loew owned it.

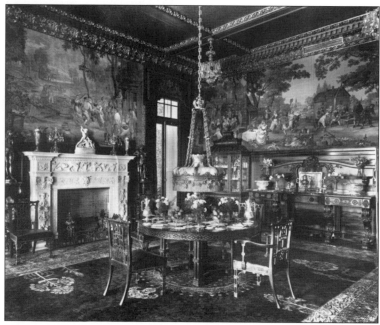

PEMBROKE, INTERIOR, 1912. No expense was spared in building Pembroke, and the interior was as opulent as any European castle. The doorknobs were sterling silver and the windows Tiffany glass. The house, designed by C. P. H. Gilbert, was razed in 1968. Today the house and gardens are gone, but the water tower has been restored, and the private harbor serves residents of the gated community, named Legend.

WINFIELD HALL, 1978. Five-and-dime tycoon F. W. Woolworth had the palatial 56-room Winfield Hall built in 1916 in North Country Colony. The C. P. H. Gilbert Beaux-Arts mansion, which replaced an earlier house destroyed by fire, has a magnificent marble staircase and an Aeolian pipe organ. Woolworth died in his home in 1919 of an abscessed tooth only four years after the house was finished. (Courtesy of Monica Randall.)

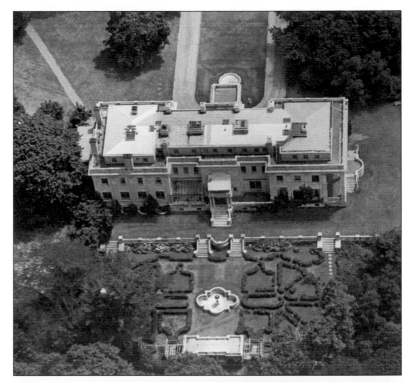

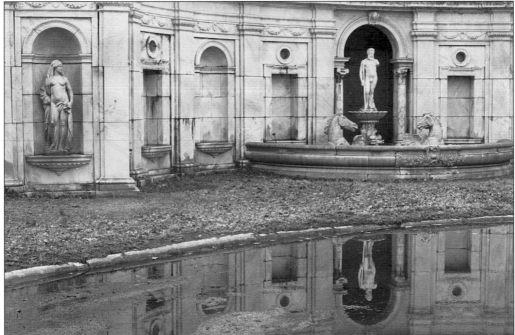

NEPTUNE FOUNTAIN, 1976. While Woolworth's eclectic interests in Egyptology, Napoleon, and spiritualism influenced the interior decor of Winfield, the gardens were Italianate in influence. This crescent-shaped marble structure with a Neptune statue presiding over winged horses stands across a grassy vista from the front entrance to the mansion. (Courtesy of the author.)

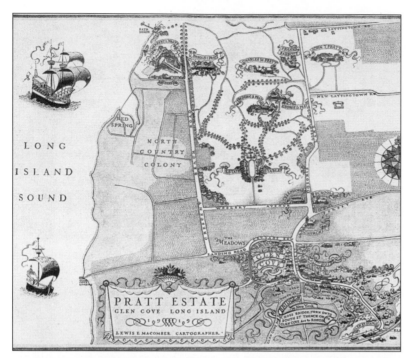

DOSORIS PARK, 1890. Dosoris, the northern area of the city, was not part of Glen Cove until after 1873. Charles Pratt, a board member of Standard Oil and the founder of Pratt Institute, bought over 1,000 acres here to create a family enclave. He gave each of his eight children funds to build a house. He died in May 1891 and only saw Seamoor and Babbot House, his oldest children's homes, completed.

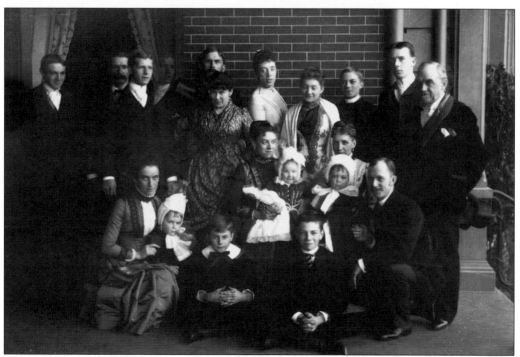

PRATT FAMILY, 1890. Charles Pratt married Lydia Ann Richardson, and they had two children, Charles Millard and Lydia Richardson (Babbot). After his wife's death in 1861, he married her sister, Mary Helen Richardson, and they had five sons and a daughter. The family assembled on the porch for this rare photograph with Charles Pratt Sr., pictured at the far right. (Courtesy of North Shore Historical Museum.)

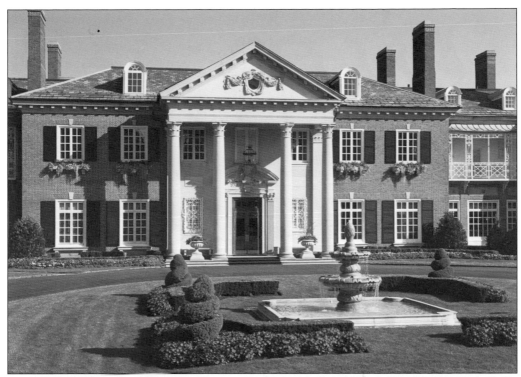

GLEN COVE MANSION, 2004. Charles Pratt remodeled this hotel and conference center, originally the John B. Coles farm, into the Pratt family manor house. After the death of his second wife, the mansion was redesigned by Charles Pratt for John Teele Pratt and his wife, Ruth Baker Sears, the first woman elected to Congress from New York State. (Courtesy of Glen Cove Mansion.)

PRATT BROTHERS, 1893. Charles Pratt had six sons. From left to right are (first row) Herbert Lee, Charles Millard, and George DuPont Pratt; (second row) Frederic Bayley, Harold Irving, and John Teele. Charles Millard, born of Pratt's first wife, was considerably older than his brothers and became secretary of Standard Oil Trust when Charles Pratt and Company (including Astral Oil) joined Rockefeller's organization. (Courtesy of Michele Kutner.)

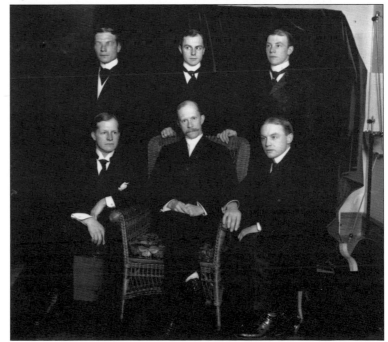

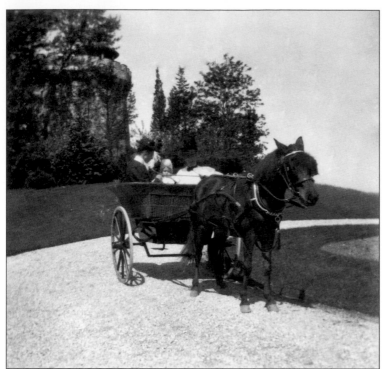

PRATT WATER TOWER, 1905. At the highest point in Dosoris, Poplar Hill, the estate of Charles Pratt's second-born son, Frederic, had panoramic views of the sound. Seen behind the carriage is the Pratt water tower, which provided adequate water pressure for all the estates in the Dosoris compound. (Courtesy of North Shore Historical Museum.)

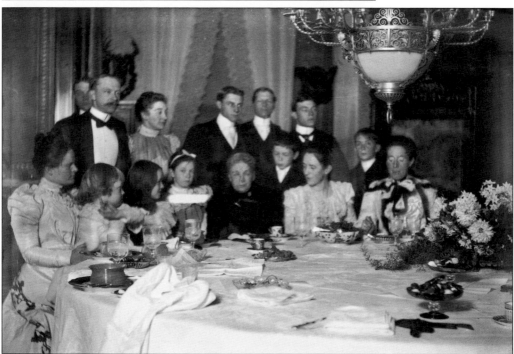

CHRISTMAS GATHERING, 1900. The Pratts were a very close-knit family, residing near each other in Brooklyn's Clinton Hill and summering together at Dosoris Park. Christmas gatherings would draw together more than 100 family members for holiday dinner at one of the family mansions. (Courtesy of North Shore Historical Museum.)

PRATT OVAL, 1930. The oval was the communications and administrative center for all the Pratt estates. The stables, garages, dairy, and farm were located here. Four hundred workers were employed in keeping the massive family complex running, and the families of employees living in Prattville, along Dosoris Lane and Woolsey Avenue, were provided with milk, eggs, and fresh produce.

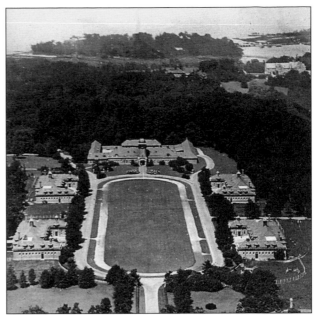

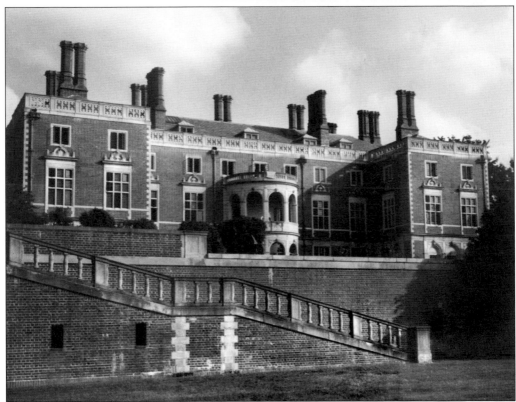

THE BRAES. This neo-Jacobean home, designed by James Brite for Herbert Lee Pratt, was the largest Pratt mansion. An art collector of note, Herbert Pratt replaced Henry Clay Folger as president of Standard Oil in 1923. The house is now Stevenson Taylor Hall, the main building of Webb Institute. The Prince of Wales landed at the Pratt dock on his 1924 trip to America.

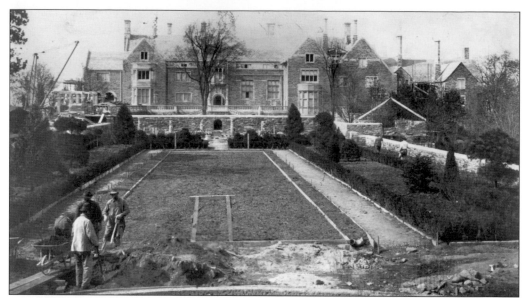

KILLENWORTH, 1914. George DuPont Pratt replaced his original shingle-style cottage with an imposing mansion designed by Trowbridge and Ackerman, his brother-in-law's architectural firm. By 1946, Killenworth was sold to the Soviet Mission. During the 1980s, the Russians were suspected of electronic eavesdropping on area defense systems, and Mayor Alan Parente and the city council banned them from the town beaches, creating an international controversy.

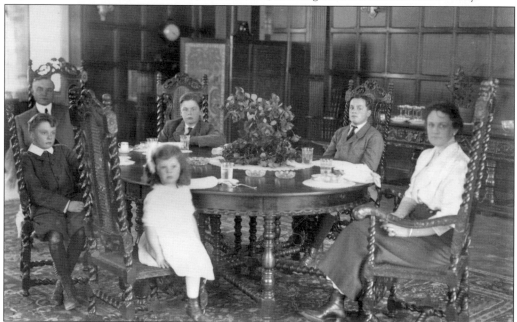

GEORGE DUPONT PRATT AND FAMILY, 1913. Killenworth was pronounced Best House of the Year by the prestigious magazine *Country Life in America*. Here George DuPont Pratt and family commemorate their first Christmas in their new home. Shown at breakfast, from left to right, are George DuPont Pratt, Sherman Pratt, George DuPont Pratt Jr., and Helen Deming Sherman Pratt. Seated in front are the youngest children, Elliot and Dorothy Pratt. (Courtesy of North Shore Historical Museum.)

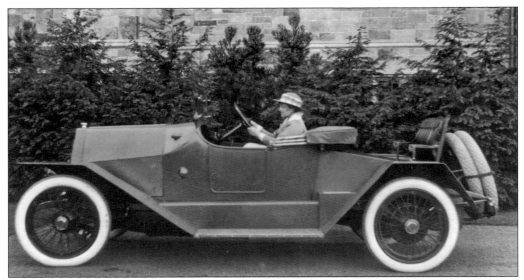

THE PRATT WOMEN. Helen Deming Pratt of Killenworth, seen here behind the wheel of her Lancia Runabout, had Lincoln Settlement House constructed at her bequest. The Pratt women were involved in many philanthropic and political causes, including suffrage. In addition to the Lincoln, Orchard, and Neighborhood Settlement Houses, schools, the library, the hospital, the post office, and several parks were funded as a result of their magnanimity. (Courtesy of Michele Kutner.)

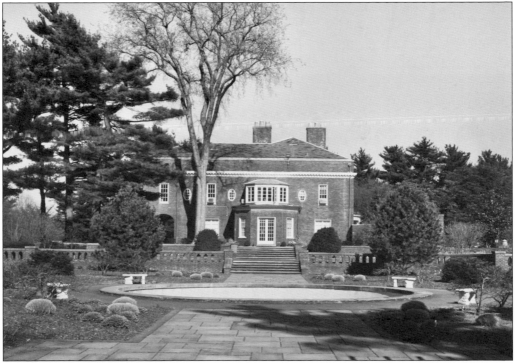

WELWYN. Lewis and Valentine Nursery planted mature elms around the home of Harold Irving Pratt. H. I. Pratt and his wife, Harriet Barnes, were benefactors of the community hospital, the library, the post office, and Pratt Park. They hosted the famous 1924 luncheon for the Prince of Wales and 200 guests on their terrace overlooking the sound.

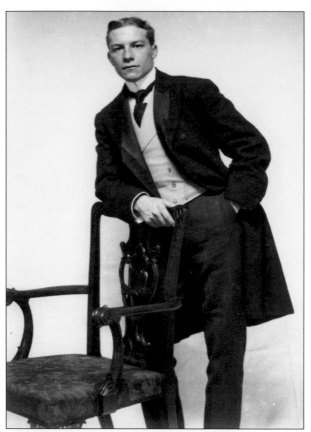

FREDERICK BAYLEY PRATT, 1893. Frederic, the third child of Charles Pratt, lived at Poplar Hill with his wife, Caroline Ames Ladd, and their three children. A graduate of Amherst College, he was president of the Pratt Institute in Brooklyn for 44 years from 1893 to 1937. (Courtesy of North Shore Historical Museum.)

AERIAL VIEW OF DOSORIS, 1938. This aerial view of Dosoris shows the old high school on the lower right, Pratt Oval on the left, and West and East Islands at the top. The sandy area west of J. P. Morgan's Matinicock Point estate was filled and built upon when Morgan's Island was developed and the east end of the island connected to Pryibil Beach.

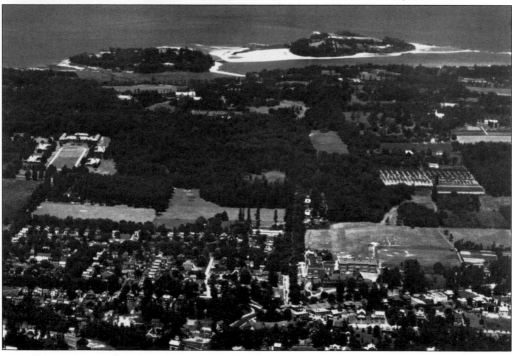

JOSEPH FARRINGTON, 1900. Joseph Farrington came from the family farm near Elm Avenue to gather clams. Shellfish were plentiful, but shell-fishing rights in Dosoris were a matter of great contention between the wealthy landowners and the townspeople. (Courtesy of Shelia Boyd and Walter Zaikowski.)

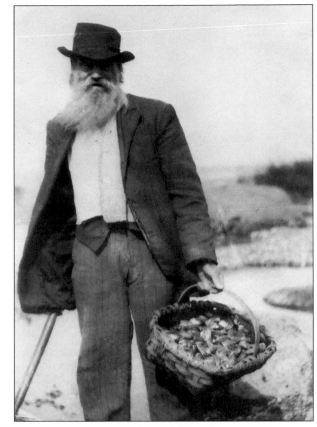

DOSORIS CREEK, 1906. This bucolic view by John F. Johnstone, superintendent of the Dana estate on West Island, shows Dosoris Creek from the new bridge looking north toward Long Island Sound. Barely visible on the left is Joseph Farrington's horse and wagon.

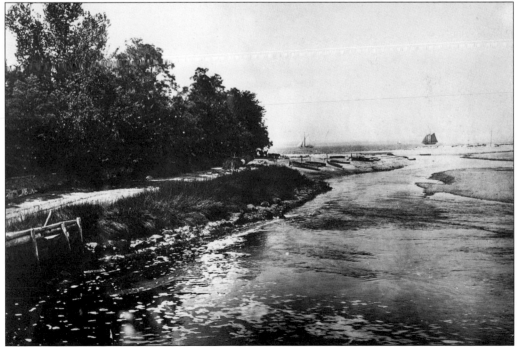

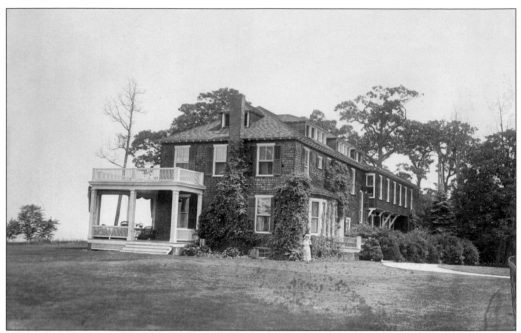

WINGS HOUSE. In 1874, Charles Dana purchased West Island property from the Coles family. The editor of the *New York Sun* newspaper surrounded his large, but modest home with horticultural specimens from all over the world. The drive down Dosoris Lane through the island was considered one of the splendors of the North Shore. (Courtesy of the Library of Congress.)

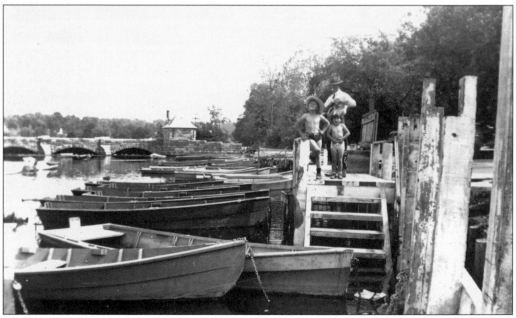

DOSORIS POND, 1953. Before the new bridge was built in 1909, there was a tidal mill on the short bridge to East Island. Jim McLoughlin lived nearby, and his bait and fishing station was popular with anglers. The business venture was not popular with the Morgan family, who tried repeatedly to hire him, buy him out, and move him, all without success.

JANE NORTON MORGAN, 1898.
In 1898, Jane Morgan was presented to Queen Victoria at Buckingham Palace. Though wife of J. P. Morgan Jr., "Jessie" Morgan was a private person who personally handled her children and multiple homes with great aplomb. When she died of sleeping sickness in 1925, she was mourned by the townspeople who knew and respected her, as well as by her family. (Courtesy of Paul and Cecily Pennoyer.)

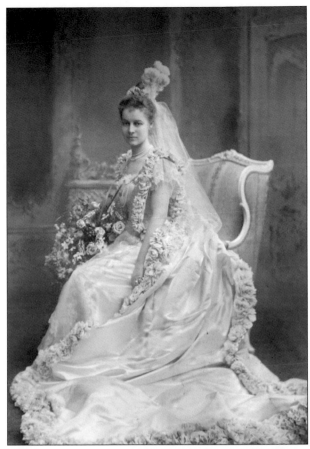

MATINICOCK POINT, 1911.
The most powerful financier of his time, J. P. Morgan Jr. hired architect Grant La Farge, son of American artist John La Farge, to design his Georgian mansion on East Island. The manse was approached through an allée of linden trees and was surrounded by formal gardens. Later it served as the Russian Mission and then a convent. It was razed in 1980.

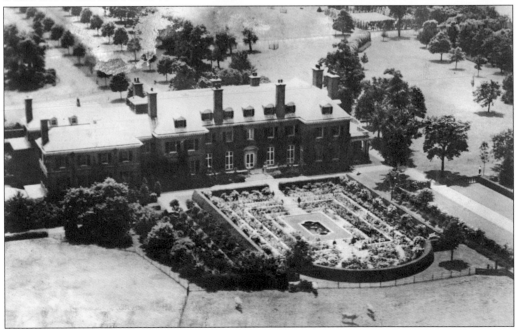

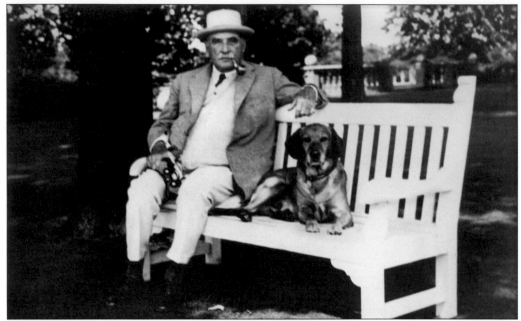

J. P. MORGAN JR., 1930. John Pierpont "Jack" Morgan Jr. was a family-oriented man who enjoyed the company of his children and his grandchildren. After the death of his wife, he led a lonely life on the big estate and spent quiet time in the rose garden with his yellow lab, Cimba. (Courtesy of Paul and Cecily Pennoyer.)

MORGAN MEMORIAL PARK, 1931. After the passing of Jane Morgan, J. P. Morgan began acquiring waterfront property in the Landing to build a park in her memory. He bought the Hall, the Vincent and Appleby estates, and West Street. The buildings were leveled, and a landscaped homage to her was created on 16 shorefront acres. The reclusive Morgan was not present when the park opened to great public fanfare in 1931.

Six

A MELTING POT

When the first colonists came to Musketa Cove, there were few native people in residence, though Matinecock artifacts, shell mounds, and arrowheads could be found in several locations until World War II. Settlers were primarily of English descent, with Dutch in the Cedar Swamp area. Freed slaves, welcomed by the Quakers, formed an early African American community.

The first wave of 19th-century immigrants, the Irish, came to work in the starch factory. They stayed to build the estates and, as a testament to their faith, St. Patrick's Church. There were Scots and Welsh, brought from Europe to work as butlers, maids, and drivers, and Germans attracted by the fervor of Methodism. The Jewish community formed in the 1890s at the home of Isaac Bessel, a horse and feed dealer who owned a Torah. The next wave of immigrants, the Poles, built St. Hyacinth's Church on Cedar Swamp Road and, in 1922, the Polish National Home on Hendrick Avenue. They worked on the estates and in the factories of the creek.

Carney's Orchard, bordering the west side of Cedar Swamp Road, became "Little Italy." The Italians, many from Calabria and Glen Cove's sister city, Sturno, were able stonemasons, laborers, and gardeners. They built the railroads, the waterworks, and palatial Gold Coast estates. The women were skilled needle workers and formed the workforce of the city's once-considerable textile industry. The Italians, and in particular the Suozzi family, have had a great influence on the social and political life of both the city and Nassau County.

A Latino community began to grow in 1950. Puerto Rican families arrived to work in the factories when mechanization of industries cut field jobs at home. *Botánicas* appeared, and in 1978, La Fuerza Unida was formed to look after educational and cultural needs of Spanish-speaking people. Political unrest in South and later Central America, particularly El Salvador, was responsible for further Latino immigration. Today the newest immigrants come from Peru, and a restaurant named for Machu Picchu is located on School Street in a storefront house that was home to the first mayor, Dr. James Burns.

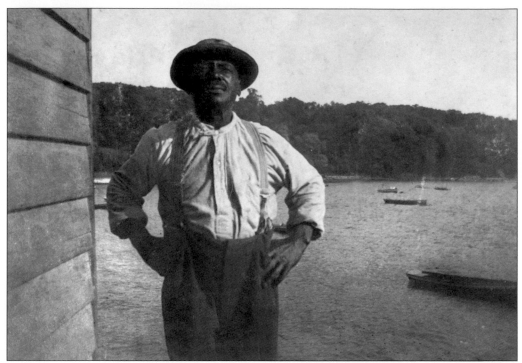

JOHN "BOP" TOWNSEND, 1896. African Americans were an integral part of the community from the earliest years. John "Bop" Townsend, who bore the surname of an early Quaker family, worked at Luyster's Store on Landing Road. The Luyster home still stands, and although the store is gone, old-timers remember it for its cracker barrel.

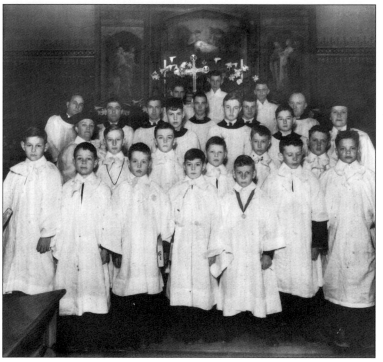

ST. PAUL'S CHOIR, 1939. St. Paul's Episcopal Church was the third religious congregation formed in Glen Cove and the house of worship of many leading families. In the first row of St Paul's men and boy's choir are (from left to right) Walter Paddison, Arthur Leach, unidentified, and George Cathcart. (Courtesy of Walter J. Paddison.)

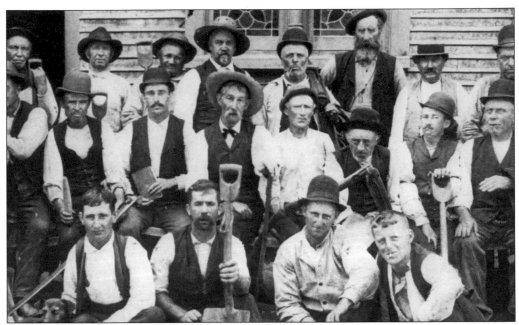

ST. PATRICK'S CREW, 1899. Francis Joseph Boyd (second row, holding book) was part of the skilled crew of predominantly Irish laborers who built St. Patrick's Church. This Irish Gothic marvel, with a bell tower that can be seen for miles, was constructed high on the hill above Cedar Swamp Road at the site of the original 1858 wood-frame building. (Courtesy of Shelia Boyd and Walter Zaikowski.)

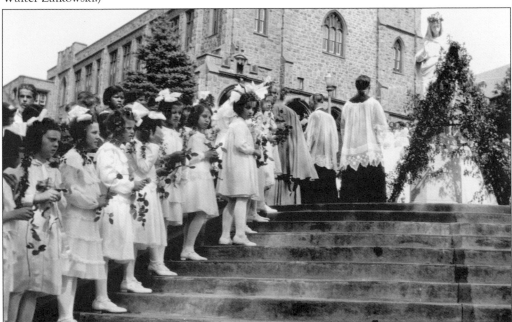

ST. PATRICK'S MAY CROWNING, 1923. In 1916, the Butler family donated the statue of the Blessed Virgin that stands atop St. Patrick's steps in honor of their relation, Mother Marie Joseph (Johanna) Butler, a nun who founded Marymount College. Each May, the statue is crowned with a wreath of blossoms by the Catholic schoolchildren. (Courtesy of Ben Dunne and Brenda Dunne Brett.)

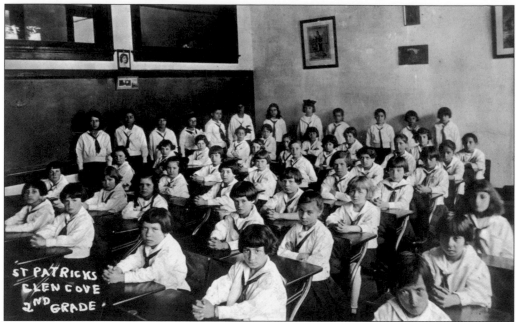

CLASS, ST. PATRICK'S SCHOOL. On St. Patrick's Day in 1914, ground was broken for a parish school. The fireproof grey granite edifice was state-of-the-art for the time. It had 18 classrooms and an auditorium that seated 1,100. The first year, 370 students were enrolled in six grades taught by the School Sisters of Notre Dame.

DONOHUE STREET, 1920. This house at 17 Crestline Street, later Donohue Street, was home to five generations of the Donohue-Colwell-Famigliette family. Agnes Donohue Colwell stands in front holding her daughter, Ellen (Famigliette). This home was part of a 90-acre parcel on Backroad Hill bought by Edgar Duryea and sold to the Irish starch workers. (Courtesy of Ann Famigliette and Susan Shilling.)

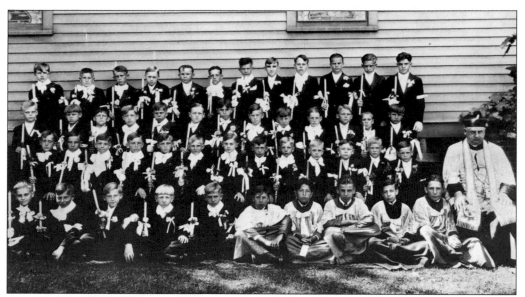

St. Hyacinth's Church. Fr. Karol Sarnecki, beloved pastor of St. Hyacinth's Church for 27 years, sits beside a group of first communicants next to the original wood-frame building. In 1909, under his guidance, Polish immigrants built this church on Cedar Swamp Road near Glen Street Station to serve the Polish community in Glen Cove and the surrounding area. (Courtesy of Carol Peise at St. Hyacinth's Church.)

Polish Wedding, 1925. Generations of local families have been baptized, confirmed, and married at St. Hyacinth's Church in traditional Polish-language services. Although a new church was built in Glen Head in 1986, the parish celebrated its 100th anniversary in 2009 and remains the spiritual center of Polish life in Glen Cove.

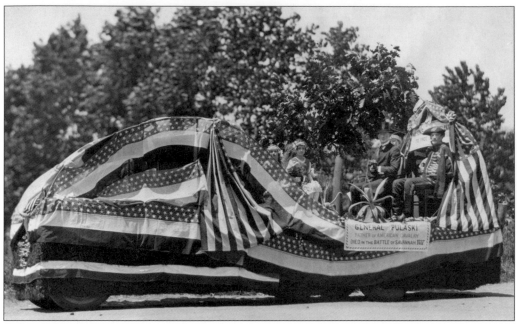

PULASKI FLOAT, 1929. The Pulaski float was built by members of the Polish National Home to celebrate the heroism of Gen. Casimir Pulaski, the father of American cavalry. Pulaski died in the siege to retake Savannah in 1779 during the American Revolution. Pulaski Street, once Mill Street, is named after this patriot. (Courtesy of the Polish National Home.)

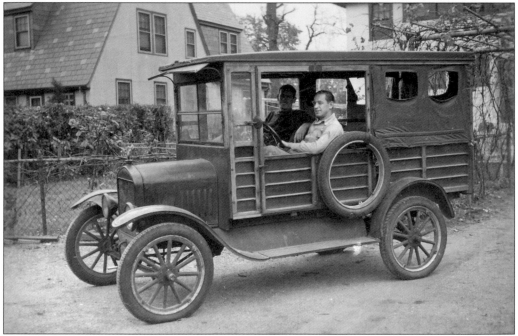

LANDING ROAD, 1929. Charles Ostafski (the driver) proudly shows off the family truck. Ostafski and his four siblings, none of whom married, lived their entire lives together in their childhood home. Their father, Alex, an estate worker at Killenworth, built the house in the Landing, then a predominantly Polish neighborhood. (Courtesy of Ellie Pucciariello.)

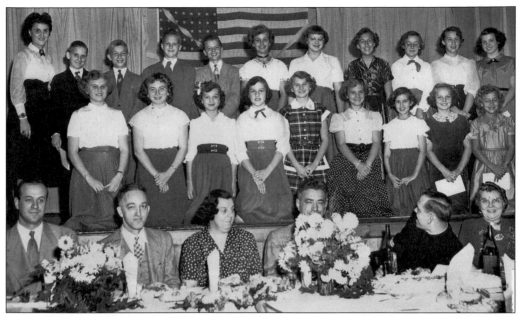

POLISH SCHOOL, 1950. Students from the Polish-language class smile from the stage of the Polish National Home. A Miss Budny, their teacher, looks on with pride, and the pastor, Joseph Kozlowski, turns to give them words of encouragement. (Courtesy of Ellie Pucciariello.)

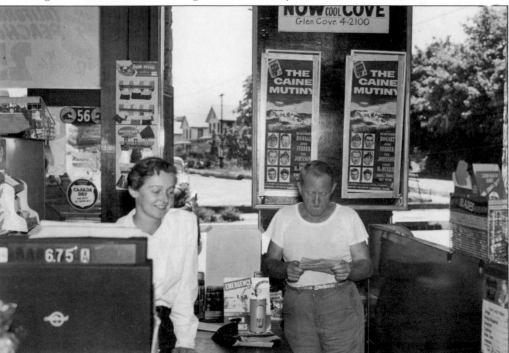

THE SUPER M, 1954. *The Caine Mutiny* was playing at the Cove, and the telephone exchange was still "Glen Cove" in 1954 when the Landing was predominantly Polish-owned and the Super M catered to the estate trade. Ellie Kaminski works the cash register at the Markowskis' store while Frank Doxey looks on. (Courtesy of Ellie Pucciariello.)

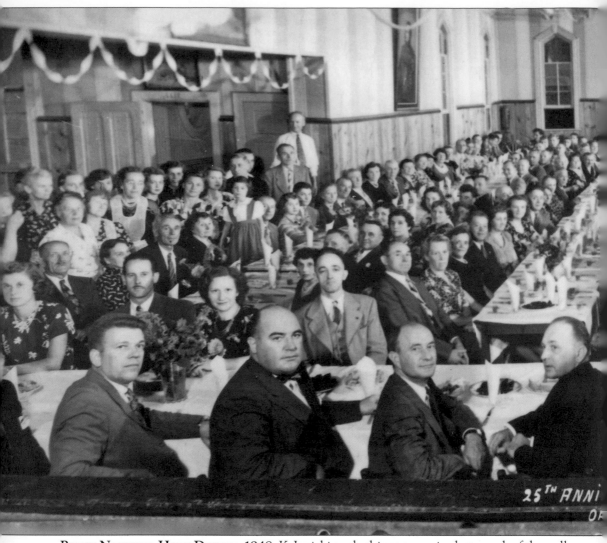

POLISH NATIONAL HOME DINNER, 1948. K. Janicki made this panoramic photograph of the well-attended 25th anniversary dinner at the Polish National Home in September 1948. The Polish

Hall on Hendrick Avenue has served as a center for Polish language, history, and culture for Glen Cove and vicinity from 1923 to the present. (Courtesy of Polish National Home.)

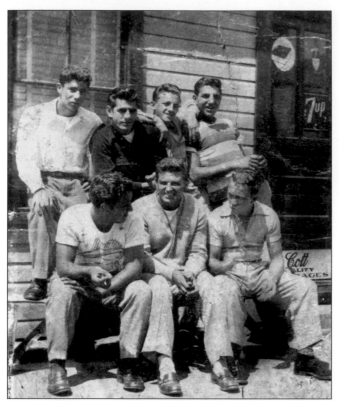

ORCHARD BOYS, 1940. The old Orchard was a unique village within the city. Marianne's candy store, with its cowbell and potbellied stove, and the many grocery stores—Montefiore's, Maccarone's, Bianconi's and Izzo's—kept the local boys well supplied with candy and, as they got older, beer and snacks. (Courtesy of Stella Cocchiola.)

DE LUCA'S, 1976. DeLuca's bar and bocce court on Hazel Street has been the social center of the Orchard for a century. Every evening, men gather there to meet friends and play *tressette*, an Italian card game. Every September, a "Pepper Party" is held to celebrate the new crop and the old heritage. (Courtesy of Cindy Carbuto Geist and DeLuca's)

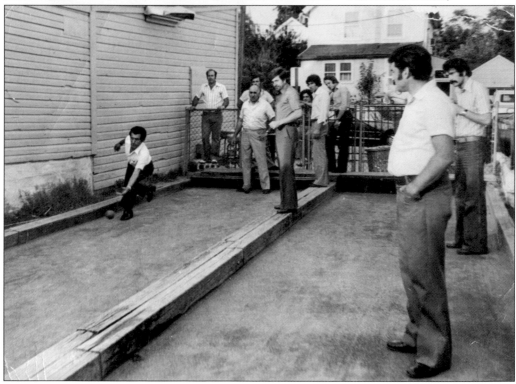

St. Rocco's Procession, 1950. The culminating procession of the Feast of St. Rocco passes De Luca's bar. In the early years the feast, sponsored by St. Rocco's Mutual Aid Society, lasted two days and took place on Hazel, Grove, and Capobianco Streets. The Opera of St. Rocco, obtained by Angelo Cocchiola from Italy, was performed. (Courtesy of Howard Stillwagon.)

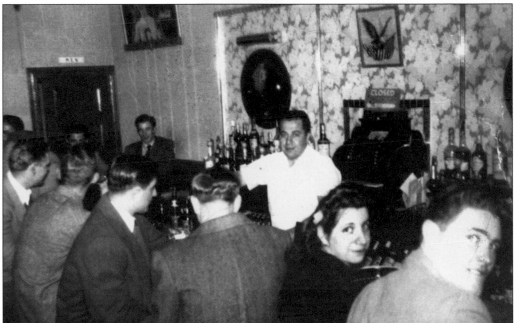

Stango's, 1946. Gabe Cocchiola tended bar in Stango's after World War II. His father, Angelo Cocchiola, was among the first group who came to Glen Cove from near Glen Cove's sister city, Sturno, Italy. Gabe married Stella Stango, whose parents founded the restaurant in 1919. Stella and their sons, Gabe and John, still preside over the bar and dining room in this 90-year-old establishment. (Courtesy of Stella Cocchiola.)

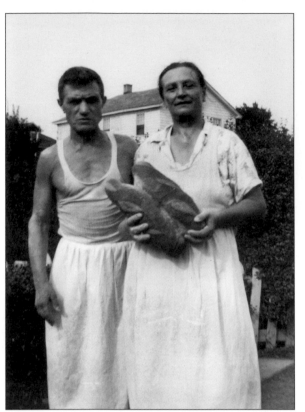

FIRST LOAVES OF BREAD, 1940. A match was arranged for Antonio Giambruno, a widower with four children, and Sabine, a widow with three girls. They married at Ellis Island aboard the boat Sabine and her daughters arrived on. The happy union produced four more children and a community bakery. Antonio and Sabine are shown holding the bakery's first loaves of bread. (Courtesy of Josephine Galante.)

GIAMBRUNO'S BAKERY, 1960. Giambruno's Bakery served the parishioners of St. Rocco's Church for more than 40 years. The family business provided bread to the local delis, and in the early years, the Giambruno children delivered milk from the family's two cows to the neighborhood. (Courtesy of Josephine Galante.)

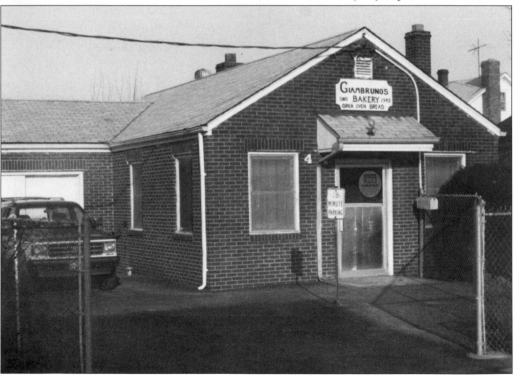

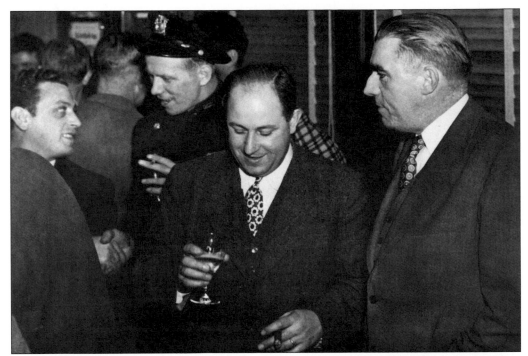

MAYOR LUKE MERCADANTE, 1947. Newly elected Democrat Luke Mercadante celebrates his upset victory and triumph as the first Italian mayor of Glen Cove. From left to right are his brother, Philip Mercadante; Officer Stanley Lupinski; Luke Mercadante; and Republican Tom Gulotta Sr., who came to congratulate a fellow Italian on his victory. (Courtesy of Brian Mercadante.)

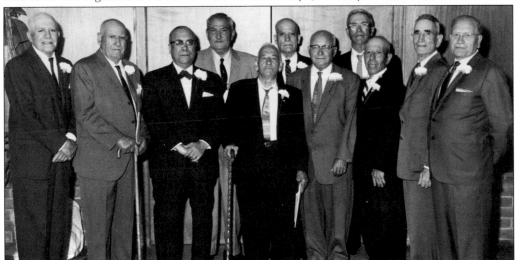

ORDER SONS OF ITALY IN AMERICA (OSIA), 1964. Giuseppe A. Nigro, with 10 fellow countrymen, founded New York State Loggia No. 1016 on April 10, 1920. The loggia preserves Italian culture and tradition, fights defamation, and provides scholarships. Founding fathers pictured here are, from left to right, Giuseppe Sanfratello, Domenick Izzo, Charles Anzalone, Angelo Genova, Carmine Caggiano, Arcangelo Macedonia, Antonio Grazioso, Vincent Gambino, Pasquale Nigro, Giuseppe Trimarchi, and Giuseppe A. Nigro. (Photograph by Joe Cardinale, courtesy of OSIA Loggia No. 1016)

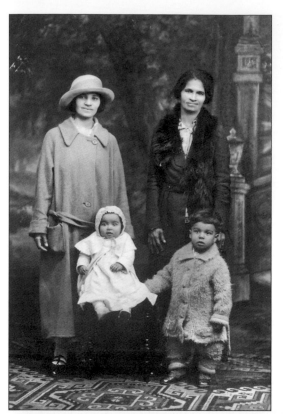

PUERTO RICAN MIGRATION, 1925. The first family that began the influx from Puerto Rico to Glen Cove put on their Sunday best for this studio portrait taken in downtown Glen Cove. Martina Gonzalez (left), with her children Dora and Cesario in the foreground, stands with her mother, Nemensia Lopez, a gifted herbalist whose healing ministry was renowned throughout the city. (Courtesy of Mercedes Morales.)

LATINO BALL TEAM, 1964. Pascual Blanco (first row, far right) initially came from Puerto Rico in 1961 to pursue a career on the stage. He became a leader of the Latino community and the guiding force behind La Fuerza Unida. Blanco has worked for decades for affordable housing and protects the interests of the Spanish-speaking residents of the city. (Courtesy of Pascual Blanco.)

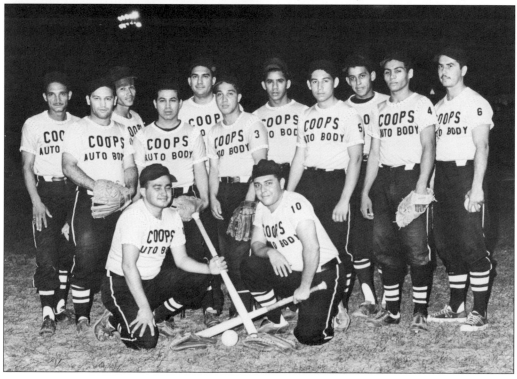

Seven

SCHOOL DISTRICT No. 5

The first district schoolhouse was located across from Carpenter Memorial Methodist Church on School Street. In 1821, funds were raised to build a larger building, and a new schoolhouse was constructed on the corner of Highland Road and School Street. A board of education formed with Thomas Garvie, George D. Coles, and Stephen Craft as trustees. At this time, less than half of the 226 school-age children actually attended school.

In 1857, School District No. 5–Town of Oyster Bay, which included the Musketa Cove Patent, was established by an act of the legislature. An even larger schoolhouse was built on the site, and this modern free public school served the district for the next 30 years. On the 225th anniversary of the founding of Musketa Cove, children of the district paraded to a brand new school building on the corner of Dosoris Lane and Forest Avenue. This architecturally distinguished edifice, built on Pratt lands and influenced by benefactor Charles Pratt's educational concepts, offered classes in craftsmanship along with academics. It was the finest school on Long Island.

A complex of school buildings grew on this site, including the 1911 building that is now the west wing of the current middle school. By 1938, the wooden high school was replaced by a larger brick building. It became the main section of Robert M. Finley Middle School in 1962, when Glen Cove High School was moved to Dosoris. Deasy School was built in 1927 to replace Central School, destroyed by fire. South and Coles Schools were constructed in 1930 to educate an ever-growing population, and Landing School followed in 1932. Deasy and Landing—the "friendly school"—are paired to serve the western and central areas of Glen Cove. South School, site of the World of Tomorrow School, now serves a larger community as SCLD (School for Communication and Language Development), and Coles School has been leased to Solomon Schechter. In 1955, East School was constructed; it was renamed Margaret A. Connolly School after a beloved teacher and principal. It is paired with Gribbin School, built in 1966, for children living in the eastern section of the city.

SCHOOL STREET, 1900. Looking south on School Street toward Glen Street, the old Union School is on the left. This main downtown thoroughfare is still called School Street, despite the fact that a school has not been located here since 1893.

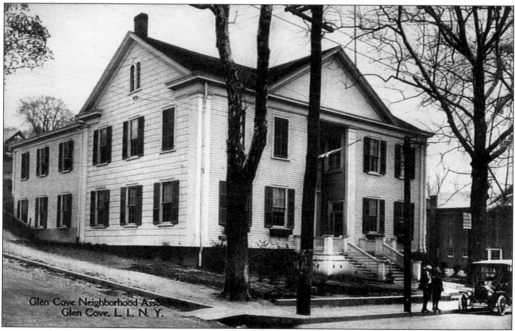

NEIGHBORHOOD HOUSE, 1910. The first Union School was located on the southeast corner of School Street and Highland Road. After the new school was opened on Forest Avenue, the building became the Neighborhood House. It was destroyed by fire on New Year's Eve in 1918.

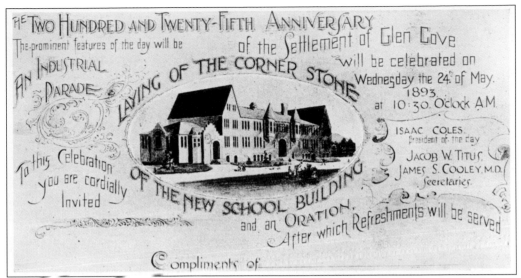

THE TWO HUNDRED AND TWENTY-FIFTH ANNIVERSARY of the Settlement of Glen Cove will be celebrated on Wednesday the 24th of May, 1893, at 10:30 O'clock A.M.

The prominent features of the day will be AN INDUSTRIAL PARADE, LAYING OF THE CORNER STONE OF THE NEW SCHOOL BUILDING and an ORATION. After which Refreshments will be served.

To this Celebration you are cordially Invited

ISAAC COLES, President of the Day

JACOB W. TITUS, JAMES S. COOLEY, M.D. Secretaries

Compliments of

NEW SCHOOL BUILDING, MAY 24, 1893. On the 225th anniversary of the settlement of Musketa Cove, the laying of the cornerstone of the new Glen Cove school was celebrated with a parade from the old schoolhouse to the new building site. In 1939, the WPA funded a newer high school, which replaced this wooden building, and in 1959, Ruth Baker Sears Pratt conveyed the present Glen Cove High School property to the district.

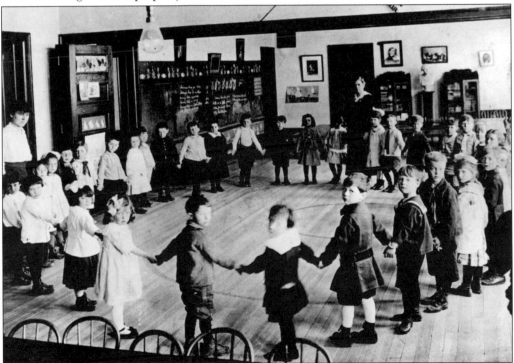

CIRCLE IN THE SCHOOL HOUSE. At the 1896 graduation ceremony, paper designs and plain sewing by the kindergarten class were much admired. In 1830, there were 104 school children and one teacher. By 1968, there were 5,000 students and 300 professionals handling the educational needs of the city.

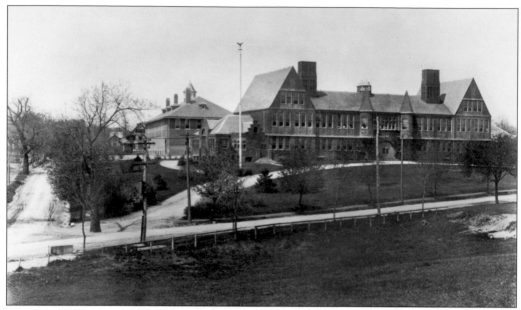

GLEN COVE SCHOOL, 1900. When this elegant new school was built on Forest Avenue, the area was still so rural that it was considered by some to be "too far out in the sticks." The school first served all 226 children but became exclusively the high school after primary and middle schools were built on the adjoining property.

SOPHOMORE PROOF, 1927. *Red and Green*, as the Glen Cove High School yearbook was known before it became the *Profile*, records the sophomore class motto for 1927 as "Aim High" and the class colors as maroon and silver. The high school also published the *Tattler*, a newspaper founded in 1925, which retailed for 3¢ a copy or 50¢ a year.

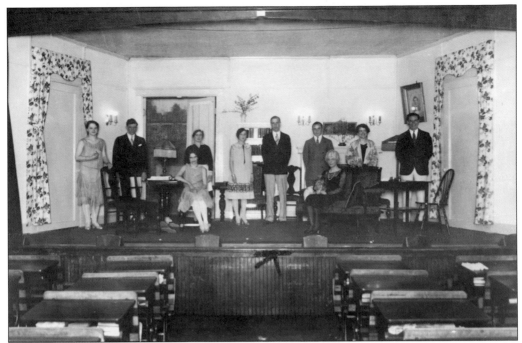

HIGH SCHOOL PLAY, 1928. On the evenings of March 7 through 10, 1928, Glen Cove High School theater students put on the comedy *The Youngest* by popular playwright Philip Barry. Barry is remembered as the author of *The Philadelphia Story*, and Glen Cove High School is known to have a strong theater program to this day.

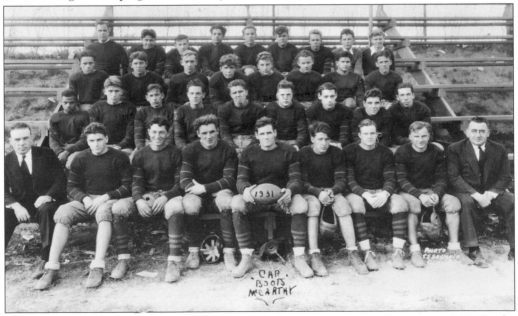

GLEN COVE FOOTBALL TEAM, 1931. The ruggedly handsome Capt. William "Boots" McCarthy and team pose for posterity in this E. J. Seymour photograph. An annual football dinner was held each year, at which the Chapman Prize for excellence in football ability, scholarship, and conduct was awarded.

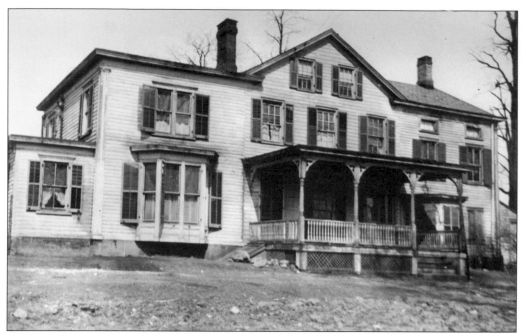

WRIGHT HOUSE, 1938. The charter of Glen Cove Library was granted in 1897, and the library was housed in the west wing of the school. From 1934 to 1938, it relocated to the Wright House on an adjoining property. This 1748 house, possibly a stop on the Underground Railroad, was leveled in 1939 for the construction of the second high school.

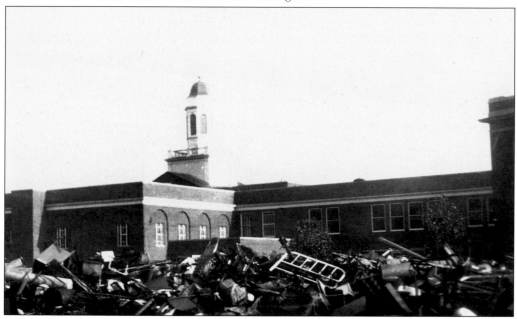

GLEN COVE HIGH SCHOOL AT WAR, 1943. In 1939, a larger brick high school opened on the site of the wooden school. Two years later, the country was at war, and metal salvaged for the war effort was collected behind the school, including the trolley tracks, ripped from the streets. This building became the main section of Robert M. Finley Middle School when the high school moved to Dosoris in 1962.

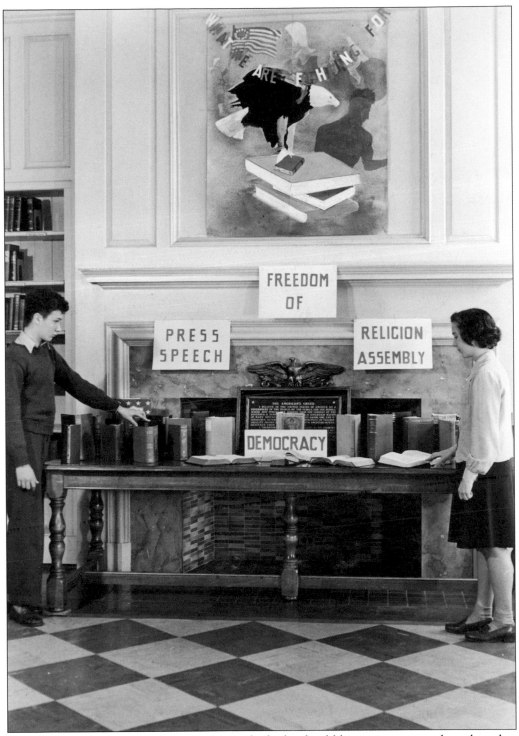

HIGH SCHOOL LIBRARY, 1943. A display in the high school library enumerates the values that the United States fought for in World War II: democracy above all; freedom of press, speech, and religion; and the right to assemble.

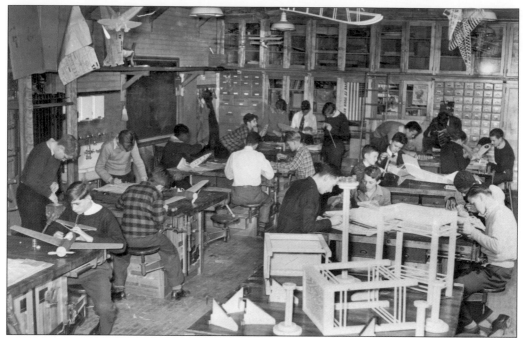

Woodshop Class, 1942. During the war years, young men in woodworking class constructed ship models for the Navy Red Cross. Pictures such as these were collected in the scrapbook *Schools at War: A Report to the Nation,* sponsored by the War Savings Staff of the U.S. Treasury Department, U.S. Office of Education Wartime Commission.

Home Economics Class, 1942. While students of both sexes now take home and careers class in middle school, students used to be divided along gender lines, with boys educated in woodworking and young women in home economics skills. This class looks on as proper childcare is demonstrated.

BASKETBALL CHAMPS, 1942. The Glen Cove basketball team, champions of 1941–1942, was coached to victory by Howard Schoen, standing at far left. Also pictured are (from left to right) players John Maccarone, John Lamberson, Henry Yoniak, James Harvey, Jack Golding, Dan Miller, Jerry Kiernan, Felix Wierzbicke, and Charles Sumcizk.

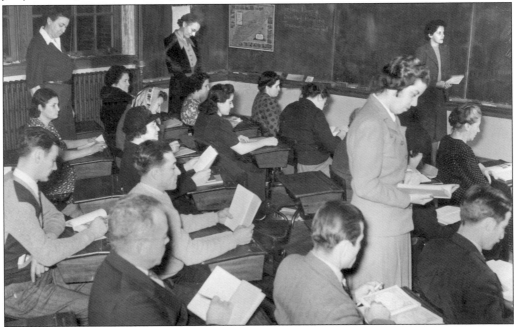

ENGLISH CLASS, 1943. Glen Cove has always been a richly diverse place, accepting of different races, creeds, and cultures. During the war years, adult immigrants could take English language classes from the faculty at Glen Cove High School. Language skills and assimilation were encouraged.

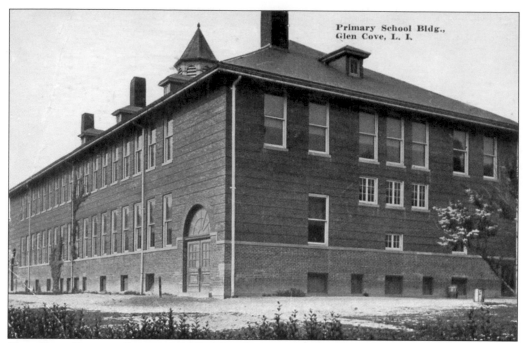

GLEN COVE PRIMARY SCHOOL, 1925. After the primary school burned down in December 1926, Central Primary School was rebuilt and named after Katherine A. Deasy, who had been a principal there. Kindergarten through third-grade students attend Deasy School.

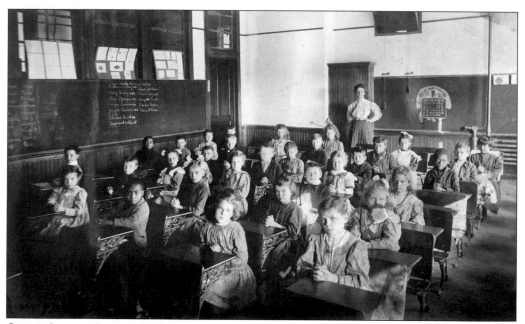

GRADE-SCHOOL CLASS. Children attending the Union School studied drawing and manual skills, as well as the academic disciplines. The well-outfitted school even had a herbarium of 5,000 plants, a gift from principal Frank Owen Payne.

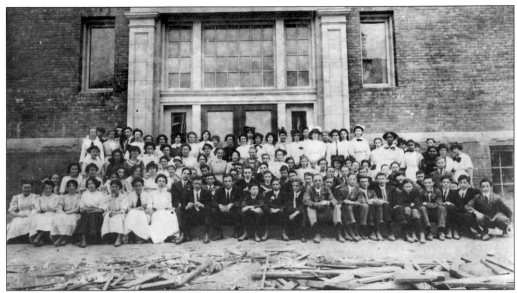

School Class Picture, 1910. In this curious image, revealing construction debris in the foreground, school pupils and faculty gather for a formal portrait. More than 100 names of those present were carefully annotated on the back of the photograph. (Courtesy of Edna Patrick Shotwell.)

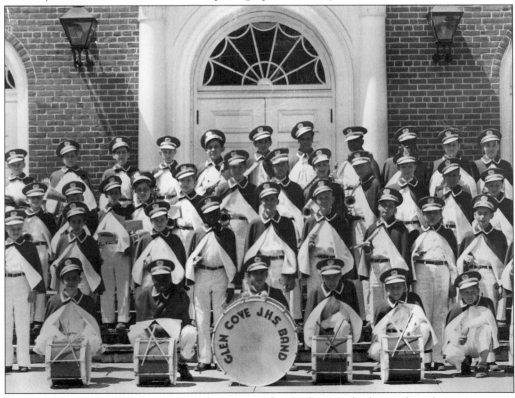

Junior High School Band. Many Glen Cove Schools alumni who learned to play instruments under patient bandmasters like Felix Sangenito fondly remember the junior high school band. The band uniforms are not remembered kindly, particularly the itchy, hot, red wool capes.

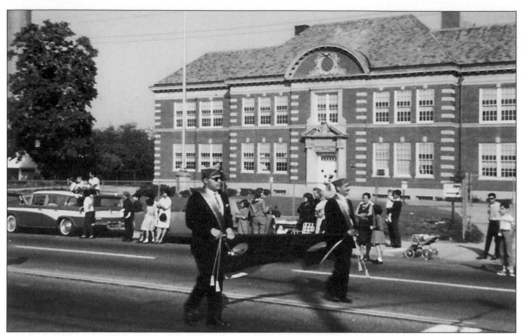

COLES SCHOOL, 1973. The Memorial Day parade passes the former Coles School, built in 1930 to serve the eastern sector of the city. The school was named after the Hon. Franklin A. Coles, president of the board of education, who spoke at the October 26, 1930, dedication. Today it remains an educational institution but is leased to Solomon Schechter for use as a Jewish day school. (Courtesy of Jan Klebukowski.)

MARGARET A. CONNOLLY, 1960. Margaret Connolly was a teacher when East School opened its doors in 1955. She subsequently became the principal and served in that capacity for 21 years, with a philosophy of finding joy and challenge in each new day. When she retired in 1976, East School was renamed Margaret A. Connolly Elementary School.

ROBERT COLES PLANETARIUM, 1970s. Robert Coles, a descendant of the first settlers, city historian, and former director of the Hayden Planetarium, was director of Glen Cove Public Schools' planetarium. Coles demonstrates his sky projector for Mayor Donald De Riggi and local school children. Coles and his wife, Edna, had a major influence on education in the city through teaching in the schools and at their Little Museum on the Place.

WORLD OF TOMORROW SCHOOL (WOTS), 1973. "Miss Ben" (Irene Harris) still hears from some of her fourth- and fifth-grade World of Tomorrow students 40 years later. The WOTS was an alternative "open" school for the middle years located in South School. Its ungraded approach to learning put an emphasis on student responsibility. (Courtesy of Jan Klebukowski.)

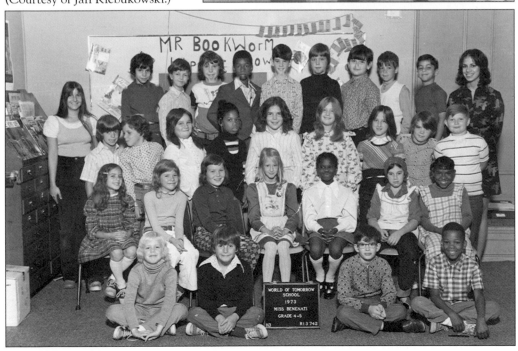

DEASY SCHOOL, 1995. David Smith leads his kindergarten class through a participatory learning exercise at Deasy School. Glen Cove schools attract devoted teachers, many of whom live in the community and serve as mentors to generations of students. (Courtesy of Michael E. Ach.)

LANDING SCHOOL'S 75TH, 2008. Alumni danced the night away at Landing School's 75th-anniversary dinner at the Swan Club. Early graduates are, from left to right, Edna Donaldson Dorfman Freeman, Elizabeth O'Neil, Edna Patrick Shotwell, Stella Stempkowski Miechkowski, Irena Kamola (kindergarten teacher at Gribbin School), and principal Michael Israel, who attended the school from kindergarten through sixth grade.

Eight

THE CHANGING CITY

Soon after the beginning of the 20th century, the abandoned starch works was destroyed by fire and the focus of industry shifted to the north side of the creek. Steamboat and trolley service ceased, replaced by the train and the automobile. Successive world wars took their toll. VFW J. E. Donahue Post 347 was founded, and streets were renamed for veterans who had made the ultimate sacrifice. By 1930, the millponds were filled and the roads paved. A modern city took shape.

In 1959, under Mayor Joseph Suozzi, blighted South Glen Cove, dating from the starch era, was designated for renewal. Forty acres by Cecil Avenue were bulldozed, and affordable housing was constructed on Backroad Hill. The firehouse and library were erected in Pratt Park around the last vestige of the ponds. When the peripheral highway was built in 1959, the Orchard lost its bucolic backyard, and the Pearsall House saw the wrecking ball.

The civil rights era brought integration of the schools and fire department. The Tricentennial was celebrated in 1968, and downtown urban renewal began. Much of School and Glen Streets were leveled, and wood-frame houses gave way to glass-faced office buildings. West Glen Street disappeared under Village Square, and drivers were encouraged to use the Brewster and Pulaski Street parking garages built by Mayor Vincent "Jimmy" Suozzi.

In 1993, Thomas Suozzi , Joseph Suozzi's son, became the youngest mayor the city has known. He merged the landmark bank buildings on Glen Street to create a vibrant new city hall and court complex. Americas' Sail came to Glen Cove, and Superfund monies were obtained to clean up the polluted waterfront. In 2002, Tom Suozzi became Nassau's youngest county executive, and Mary Ann Holzkamp became the first woman mayor. Glen Cove got the Avalon apartments and a contract for waterfront development. By 2007, the last two factories—Konica Minolta on the leatherworks site and Photocircuits plant on Sea Cliff Avenue—closed, ending the industrial era. Since 2005, Ralph Suozzi, Vincent Suozzi's son, has been mayor, and under his leadership, the city is facing the challenges of the 21st century.

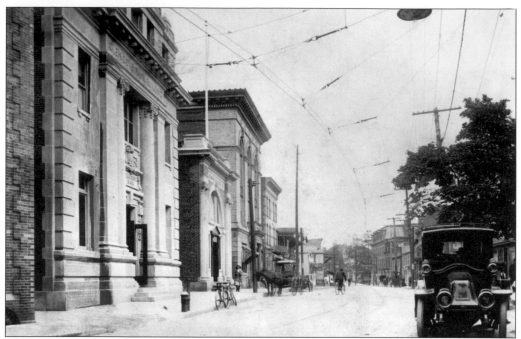

GLEN STREET, 1905. In 1995, the Glen Cove Bank and Nassau Trust Buildings were connected and repurposed into the city hall and courthouse, ensuring that this landmark view of the northeast corner of Glen Street would stay the same for generations to come.

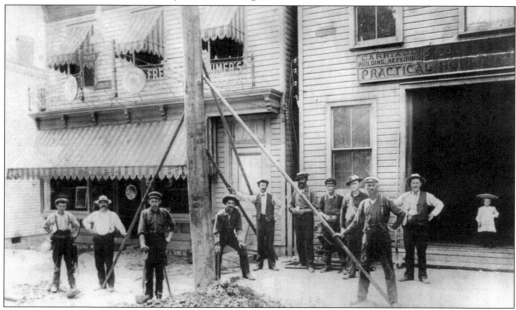

NASSAU LIGHT AND POWER COMPANY, 1905. The electrification of the city began just after the beginning of the 20th century. Workmen installing power lines in front of F. A. Ludlam's carriage and blacksmith shop on School Street included William Sniffen, lineman; John Darby, groundman; Edward Lee Smith, groundman; Edward Wansor, lineman; Everett Smith, assistant foreman; David Biggers, groundman; Harry Fling, lineman; and John Britt, groundman. The child at far right is unidentified. (Courtesy of Linda Darby.)

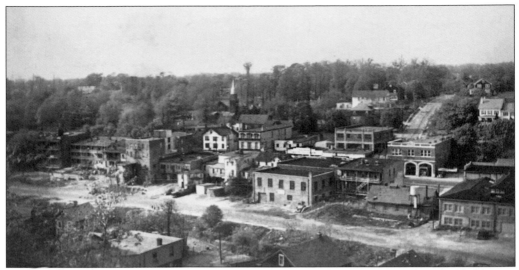

VIEW OF GLEN STREET, 1935. St. Paul's Tudor Gothic church presided over Glen Street until the late 1940s, when it was rebuilt on the Zabriskie property facing Highland Road. Modern office buildings and apartments have replaced the streetscape in the foreground, but much of the north side of Glen Street remains intact and looks as it did in the early 20th century. (Courtesy of North Shore Historical Museum.)

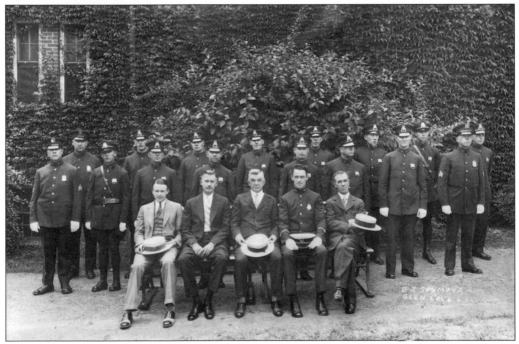

CITY OF GLEN COVE POLICE DEPARTMENT, 1928. Frank V. McCue was appointed chief of the Glen Cove Police Department on May 15, 1928, and served until his retirement on July 10, 1970. He holds the record for the longest term of service as a police chief in New York State. Seated below Glen Cove's finest are, from left to right, Tom McCarthy, city attorney; Sterling Mudge, finance commissioner; Mayor William Seaman; Frank V. McCue, chief of police; and John Gammack, commissioner. (Courtesy of Ralph R. Bruschini.)

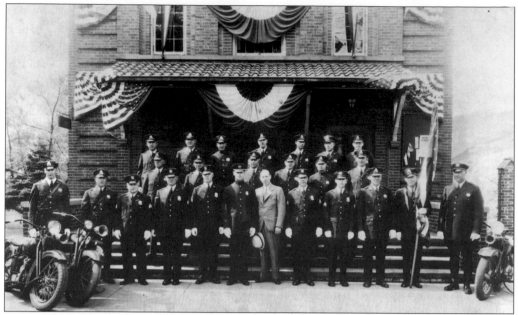

POLICE HEADQUARTERS, 1931. The Glen Cove Police Department poses for its annual photograph in front of the justice courts building, which had become police headquarters. The brick edifice, which served as a quarantine hospital during the 1918 influenza pandemic, is now being restored as the North Shore Historical Museum. (Courtesy of Ralph R. Bruschini.)

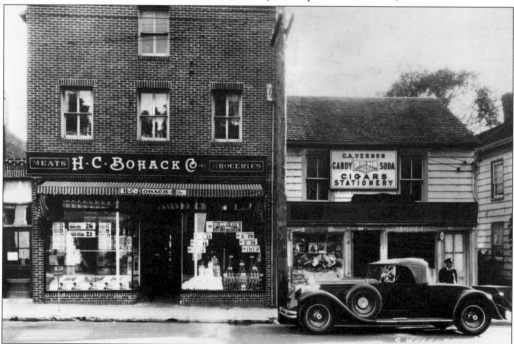

H. C. BOHACK AND C. A. VERNON'S, 1940. Bohack's chain supermarket was a popular downtown grocery before the major markets moved to the shopping centers along Forest Avenue. Chuck steak retailed for 21¢ a pound. Next door, Vernon's stationery store carried cigars, candy, soda, and ice cream.

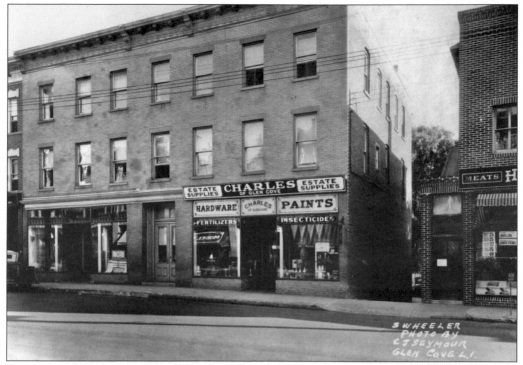

CHARLES OF GLEN COVE, 1940. Several generations of Glen Covers have entrusted their household paint and hardware needs to this well-stocked emporium on Glen Street. The store initially catered to the carriage trade and advertised that it carried "estate supplies."

RED CROSS AMBULANCE CORPS, 1941. H. Bogart Seaman (center) charms the nurses of the Red Cross Ambulance Corps as they look under the hood of a new emergency vehicle. Seaman, born into an old Quaker family, was sworn in as mayor on January 1, 1942, but resigned the position in May of the same year to serve in the armed forces. (Courtesy of Ellie Pucchiariello.)

BUTCH, 1946. Butch, a 240-pound St. Bernard belonging to Ann Miller of Forest Avenue, became the symbol of normalcy after World War II. His voluminous appetite and clever antics were a source of wonder. He was immortalized in a comic book, a *Life* magazine article, and a Republic Pictures feature film that premiered at the Cove Theatre. (Courtesy of Special Collections, Michigan State University.)

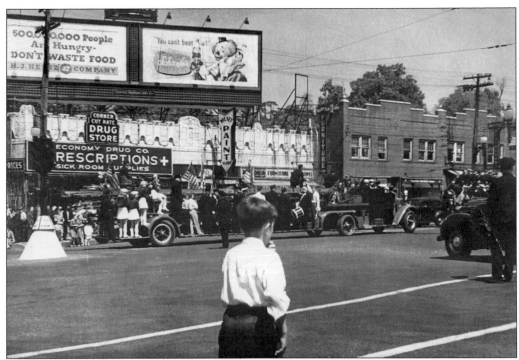

ECONOMY DRUG COMPANY, 1945. A parade during the war years passes the corner of West Glen and School Streets. The Economy drugstore on that corner catered to the community's pharmaceutical needs at affordable prices. Billboards atop the building advertise Schaefer Beer and Heinz 57 Varieties, while cautioning the wartime consumer not to waste food.

FAMILY OF FIREMEN, MAY 31, 1941. The Reynolds family holds the record for the most siblings in the Glen Cove Volunteer Fire Department at one time. From left to right are unidentified, Howard Reynolds, John Reynolds, Edwin Reynolds, Daniel Reynolds, and Joseph Reynolds. Reynolds Road is named after Howard, who was lost at sea during World War II when his destroyer, the USS *Warrington*, went down in a hurricane. (Courtesy of Richard Reynolds.)

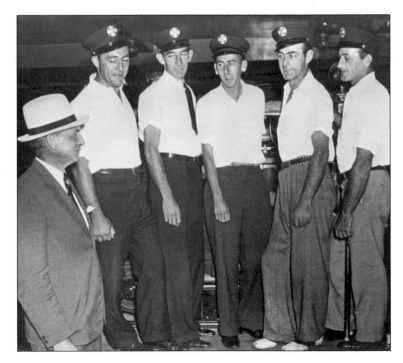

WHELAN DRUGS, 1940. Former blacksmith F. A. "Gimlet" Ludlam bought the Oriental Hotel and the adjoining livery stable in its final days, when it was known as the Ambassador. He leased it to a New York concern that lowered the building to one story and rented the corner store to Whelan Drugs. (Courtesy of Richard Smith.)

STEISEL BUILDING, 1976. The Steisel building, next to the Mutual Insurance Company, replaced the Steisel hardware store after a fire in 1937. Maurice Steisel, along with F. A. Ludlam, owned most of the commercial real estate in the city. Charles of Glen Cove was the next occupant of the building. (Courtesy of Vincent Martinez.)

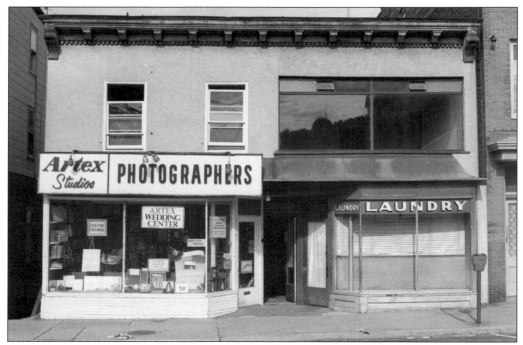

ARTEX AND THE LAUNDRY, 1973. Artex Studios was a local photography studio in business for more than a quarter century in various locales in town. It shared this School Street building with the Chinese hand laundry in the early 1970s. According to the lease, King Hung May's rent on the laundry was just $960 a year. (Courtesy of the author.)

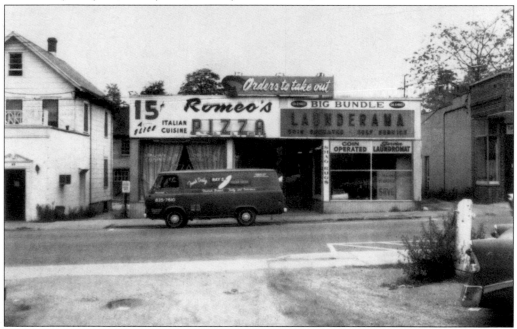

ROMEO'S PIZZA PARLOR, 1967. Before urban renewal, Romeo's on upper School Street was the place to have a 15¢ slice and a Coca-Cola while one's clothes were tumbling in the dryers at the Big Bundle Launderama. (Courtesy of Vincent Martinez.)

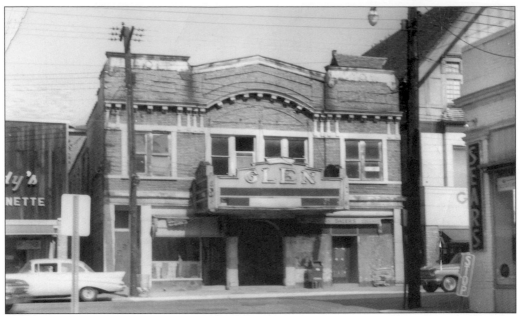

GLEN THEATRE, 1967. The Glen Theatre, the first real cinema in town, featured silent films and vaudeville on Wednesdays and Saturdays. Wednesday nights also featured a farmers' market. The aged movie palace became a symbol of urban renewal and was demolished in 1967. (Courtesy of Vincent Martinez.)

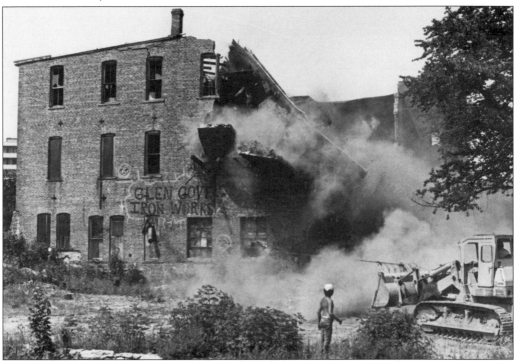

IRONWORKS, 1975. The Glen Cove Structural and Ornamental Iron Works, behind 37 School Street, was built from starch works brick in 1908. This large warehouse, located in the rear of F. A. Ludlam's blacksmith shop, saw the wrecking ball during urban renewal. (Courtesy of Frank Uhlendorf.)

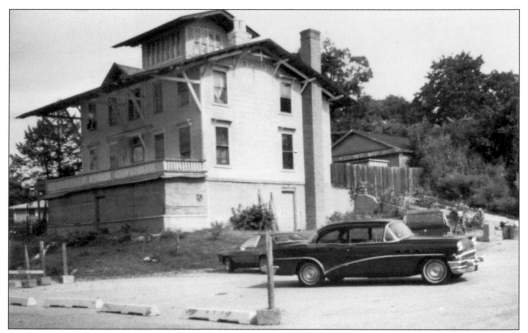

SANFRATELLO'S, 1967. Pearsall's railroad freight building near Glen Street Station became Sanfratello's grocery store. Although listed in the Society for the Preservation of Long Island Antiquities survey of historic buildings, it was torn down for the construction of a Burger King. (Courtesy of Vincent Martinez.)

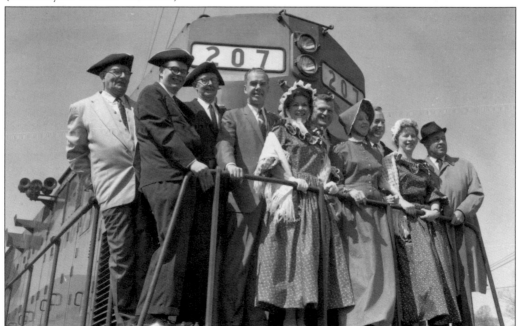

TRICENTENNIAL KICKOFF, MAY 16, 1967. A jubilant Tricentennial committee and local politicians climbed aboard the 10:15 a.m. train on arrival at Glen Street Station. The event commemorated the 100th anniversary of train travel to the city and marked the start of the yearlong celebration of the founding of Musketa Cove.

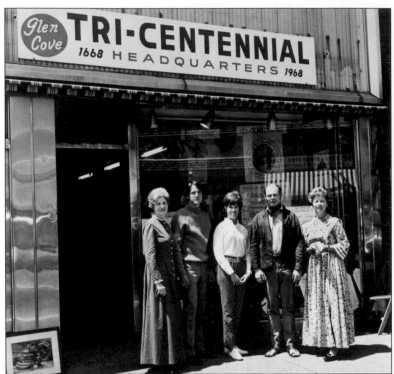

Tricentennial Headquarters, 1967. Juanita Carroll (far left) and award-winning artists of the Greenwich Village sidewalk art show pose with Maggie Polk (far right) in front of the Tricentennial headquarters. Polk, chairperson of the Tricentennial committee, later made an unsuccessful bid to be the first woman mayor of Glen Cove. (Courtesy of North Shore Historical Museum.)

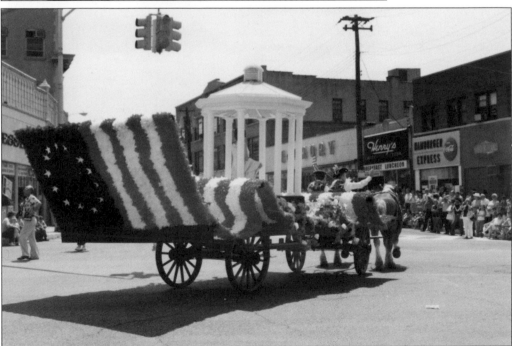

Tricentennial Parade, 1968. The Morgan Park Music Festival float rounds Oriental Corner, past Hamburger Express and Henry's, during the four-hour parade culminating Tricentennial festivities. The celebration included an original musical pageant, *This Place of Rushes*, which portrayed the history of the community. (Courtesy of Marguerite Suozzi.)

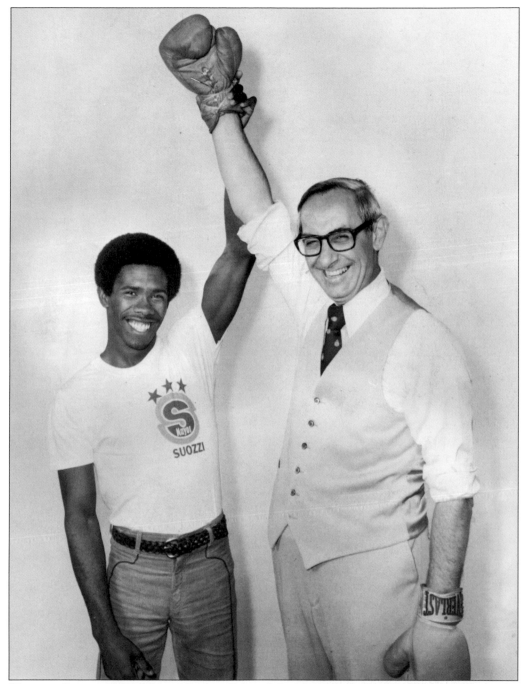

HOWARD DAVIS, 1976. Mayor Vincent "Jimmy" Suozzi raises the hand of Howard Davis, the 1976 Olympic boxing gold medalist, in triumph. The eldest of 10 children, Davis was taught to box by his father. After his Montreal Olympic win he turned pro and today trains mixed martial arts fighters. In July 2009, Davis returned to Glen Cove to see Mason Drive renamed Howard Davis Drive in his honor.

VINNIE'S ISLAND, 1984. In 1861, a liberty pole was erected at Union Square, the intersection of Cottage Row and School Street, to mark the start of the Civil War. Today the flagpole is on "Vinnie's Island," a traffic median in the same location. Vincent Martinez, a former fireman, World War II veteran, and leading citizen who spearheaded the Glen Cove Beautification Program, cares for the tiny garden. (Courtesy of Vincent Martinez.)

WORLD WAR I VETERANS, 1980. The last great gathering of Glen Cove veterans of World War I is pictured in front of the library after the 1980 Memorial Day parade. VFW James Erwin Donohue Post 347 on Hill Street maintains the VFW mission to "honor the dead by helping the living" and plays an active role in the community.

RED SPRING GARAGE. Although Simeone Classic Cars has closed, vintage cars remain a citywide passion, and Thursday night downtown is Car Cruise Night. Red Spring Garage on Landing Road stayed an automotive center for nearly a century under various owners. From left to right, Nick Simeone, Joseph James Simeone, John Simeone Sr., Joseph J. "Jody" Simeone Jr., and Jim Simeone share lunch in front of the family business.

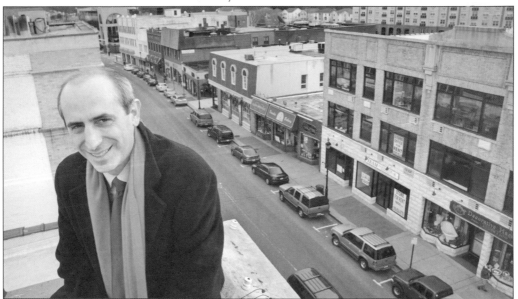

MAYOR RALPH SUOZZI, 2005. Ralph Suozzi, the 22nd mayor of Glen Cove, surveys the city from the top of city hall during his first week in office. As steward of Glen Cove's future, Suozzi oversaw the development of a new comprehensive master plan, the first in 50 years, that is intended to influence land use and balance growth and economic expansion. (Courtesy of Michael E. Ach.)

www.arcadiapublishing.com

MAP SEARCH

Discover books about the town where you grew up, the cities where your friends and families live, the town where your parents met, or even that retirement spot you've been dreaming about. Our Web site provides history lovers with exclusive deals, advanced notification about new titles, e-mail alerts of author events, and much more.

MADE IN THE USA

Arcadia Publishing, the leading local history publisher in the United States, is committed to making history accessible and meaningful through publishing books that celebrate and preserve the heritage of America's people and places. Consistent with our mission to preserve history on a local level, this book was printed in South Carolina on American-made paper and manufactured entirely in the United States.

This book carries the accredited Forest Stewardship Council (FSC) label and is printed on 100 percent FSC-certified paper. Products carrying the FSC label are independently certified to assure consumers that they come from forests that are managed to meet the social, economic, and ecological needs of present and future generations.

FSC
Mixed Sources
Product group from well-managed forests and other controlled sources

Cert no. SW-COC-001530
www.fsc.org
© 1996 Forest Stewardship Council

Find Your Place in History.